HAUNTED DAYTONA BEACH

Dave,
Happy
Hauntings!.
Thank you for your
wonderful donation to
the I A C P, Inc. raffle!
You are a talented young
man. Warm regards,
with
Dorothy
Smith
10-2007

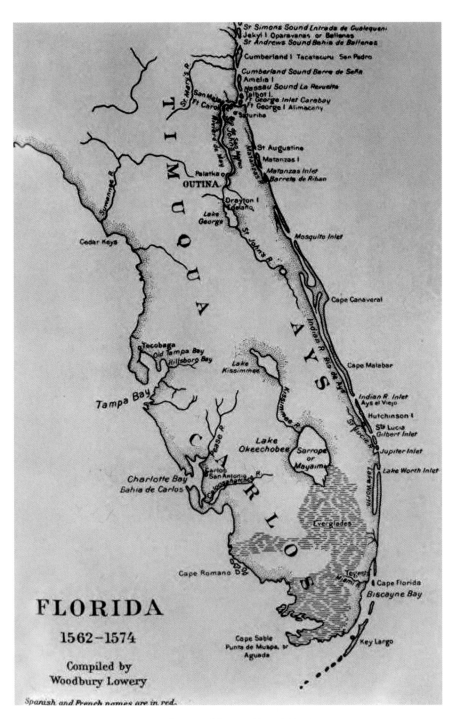

Map of Florida from the 1500s. *Courtesy of State Archives of Florida.*

HAUNTED DAYTONA BEACH · DUSTY SMITH

A GHOSTLY TOUR OF THE WORLD'S MOST FAMOUS BEACH

HAUNTED
America

Published by Haunted America
A Division of The History Press
Charleston, SC 29403
www.historypress.net

Cover design: Marshall Hudson

First published 2007

Manufactured in the United Kingdom

978.1.59629.341.0

Smith, Doris (Doris "Dusty")
Haunted Daytona Beach : a ghostly tour of America's most famous beach /Doris
"Dusty" Smith.
p. cm.
ISBN 978-1-59629-341-0 (alk. paper)
1. Ghosts--Florida--Daytona Beach. 2. Haunted places--Florida--Daytona Beach. I.
Title.
BF1472.U6S59 2007
133.1'2975921--dc22
 2007027623

Notice: The information in this book is true and complete to the best of our knowledge. It is offered without guarantee on the part of the author or The History Press. The author and The History Press disclaim all liability in connection with the use of this book.

This book is dedicated to the founding fathers and mothers, risktakers and lawbreakers that made Daytona Beach what it is today. May their spirits rest in peace.

Contents

Acknowledgements

To my son, Kyle: Thank you for putting up with your crazy mom and all of her silly adventures. I hope it has taught you to follow your dreams, be yourself and not care how other people perceive you.

To my friend, Heather Olson: Thank you for continuing your support of DBPRG, Inc.; IACP, Inc.; me and all of my endeavors. You are a true friend!

To my friend, Michele Dragone: Thank you for everything you do to help me in my life, work and pursuits.

To my friend, Mike Dragone: Thank you for always making me laugh.

To my sister, Colleen Miller: Thank you for taking such a great photo of me!

To my friend, Frank Perrick: Thank you for being you!

To my friend and fellow tour guide, Jay Ackerman: Thanks for all you do for the tours and for me!

To Dr. Ed Craft: Thank you for giving me a chance and for sharing your experience with me. Go Magick Mind Radio!

To my husband, Steven: Thank you for supporting me and for never judging me or what I do. Thank you for being by my side through thick and

thin and for taking the leap of faith in marrying me. Thank you for your suffering and pain that brought you back to me and forced you to grow. Welcome home, my love!

And to all of the members of **DBPRG, Inc.**; **IACP, Inc.**; the paranormal community and the cemetery preservation and restoration community: Thank you all for your support, help and advice over the years. I couldn't have done anything without all of you!

Introduction

Have you ever heard a voice in the night and convinced yourself it must be your imagination? Ever caught a shadow out of the corner of your eye and told yourself you were seeing things? Has a chill ever gone down your spine and you just thought it was a draft? Do you dare to wander the moonlit streets of Daytona Beach after reading this book?

Daytona Beach has long been known for NASCAR racing, spring break, Bike Week and Biketoberfest, but until now, it has *not* been known for its numerous hauntings.

Daytona Beach's history didn't start with NASCAR or bikers; it started with the Native Americans and when the Spanish first arrived in St. Augustine. The slaughtering of the French Huguenots brought St. Augustine and Daytona Beach together early on. Two survivors of this massacre made their way to Daytona Beach in the late 1500s. These survivors were cared for by the local Native Americans until they could make their way to Mexico and board a ship back to England.

Since that time, Daytona Beach has been host to harlots, rumrunners, entrepreneurs and many hardworking citizens who lost their lives in the area known as "The World's Most Famous Beach."

Since I am a certified ghost hunter and certified paranormal researcher, the founder of the Daytona Beach Paranormal Research Group, Inc. and the owner and chief operator of Haunts of the World's Most Famous Beach ghost tours, I decided it was high time to let the world in on one of Daytona Beach's best-kept secrets. It's ghosts!

The stories you are about to read are not folklore. They are actual hauntings that have been documented by the Daytona Beach Paranormal Research Group, Inc. and its members. We began researching these stories

in 1997 and still have many more locations in the Daytona Beach area to document.

Whether you believe in ghosts or just enjoy history, this book will take you on a spirit-filled ride throughout the Daytona Beach area that will make you question those things that go bump in the night!

1

The Doctor with the Missing Skull

The mausoleum in the farthest northeast corner of Pinewood Cemetery is the resting place of Adler Schon Rawlings. Dr. Rawlings was a very prominent resident in the Daytona Beach area. He was the first chief of staff at Halifax Medical Center in 1928. Dr. Rawlings, like many physicians of his day—or any other—enjoyed golf as a relaxing pastime.

The place to be seen in the Daytona Beach area in those days was at the Riviera Hotel and Resort, in Ormond Beach. The Riviera boasted a three-hundred-foot boat dock, piano lounge, restaurant, polo and hunt clubs, gondola rides in the canals and, of course, a wonderful golf course. The affluent from all over the world spent leisurely days at the Riviera. Dr. Rawlings was among them. On many a fine sunny afternoon, Dr. Rawlings could be seen teeing off on the resort's golf course.

Dr. Rawlings did quite well for himself in the Daytona Beach area, not just as a brilliant physician, but as a well-mannered socialite. He fit right in at any event he attended. After being appointed chief of staff, his already successful life became even more successful. Even though he had prepaid and preplanned for his entire funeral and burial site, he could never have anticipated what the future held for Daytona Beach.

Dr. Rawlings's mausoleum was the most expensive ever built in Volusia County up until 1984. It has a Tiffany stained-glass window, brass flower holders, death lamps and mourning benches and is made entirely out of two-foot-thick Peruvian marble. He even commissioned an artist in Europe to design very ornate brass gates in the shape of olive trees.

Dr. Rawlings passed from this world in December of 1948, just two days before Christmas. Shortly after he was laid to rest, vandalism in Pinewood Cemetery reached its height. On many nights, transients entered the

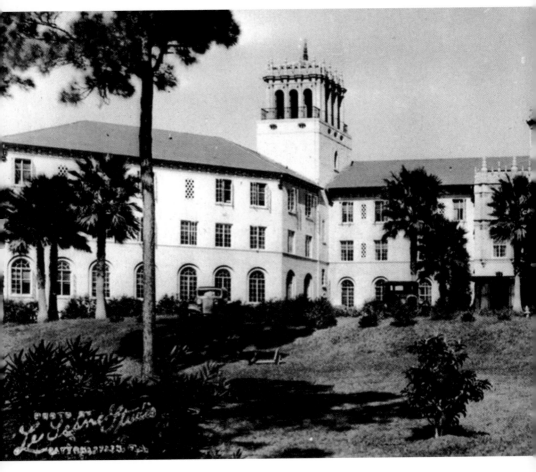

Halifax Medical Center. *Courtesy of State Archives of Florida.*

grounds and slept wherever they could. Some even broke into crypts to bed down for the night. It had also become popular for local teenagers to hang out in the cemetery and tell one another scary stories. Some teenagers, however, didn't stop at just telling stories.

In Daytona Beach, there are few places for local teens to hang out. Most locations have security guards who harass teens to make sure they are not runaways or up to any funny business. In 1972, a group of local teenagers decided they had enough harassment and they left the boardwalk area. They wound up in Pinewood Cemetery, trying to find a place to hang out where no one would bother them. Since this happened in a time before the busy Ocean Center, the most likely spot was Dr. Rawlings's resting place, as it had the fewest peering neighbors. They removed the brass gates that hung in the doorway, destroying them in the process, and entered the mausoleum. They

14

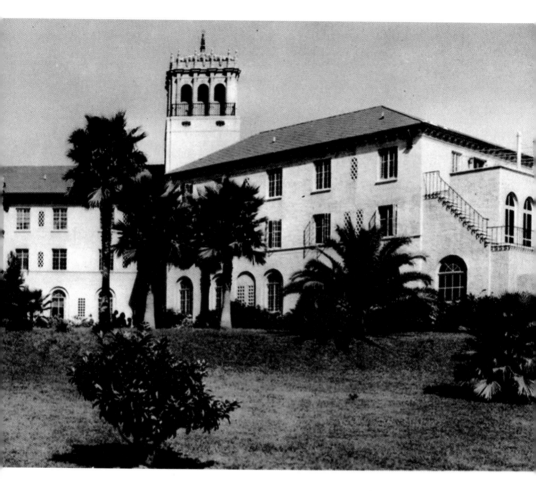

set up candles for lighting and used his coffin as a card table. They marked their territory by spray painting graffiti, obscenities and their nicknames on the inside and outside of Dr. Rawlings's final resting place. The mausoleum became a clubhouse for this group of local youth. As their membership grew, they decided the clubhouse was a bit crowded and that Dr. Rawlings, who wasn't really a contributing member, would have to leave.

The teenagers removed Dr. Rawlings's casket from the mausoleum and decided to take a look inside. When they had seen enough, they threw the casket and the remains of Dr. Rawlings into the street on Auditorium Boulevard. Then the group of youths decided to play a game of golf! They used Dr. Rawlings's long bones and skull to play their eerie game.

The following morning, police and city workers retrieved Dr. Rawlings's remains. Dr. Rawlings was returned to his resting place and his mausoleum was sealed shut with concrete block so that no one could disturb his final resting place again. However, his skull was never recovered.

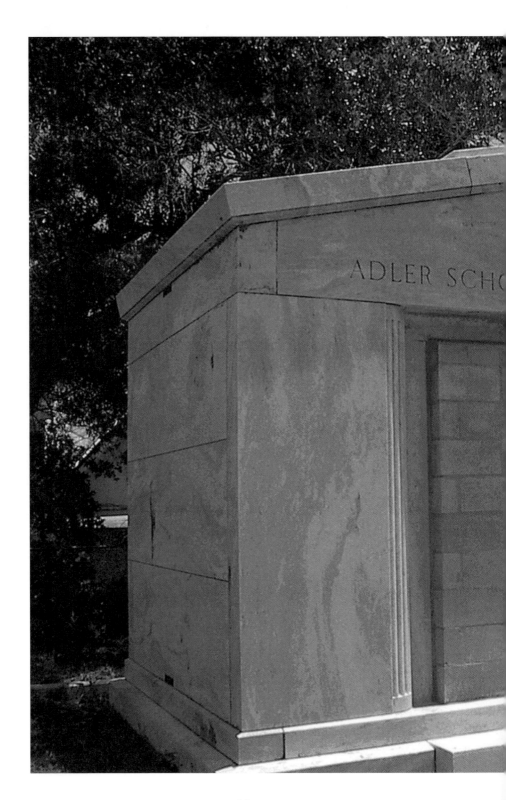

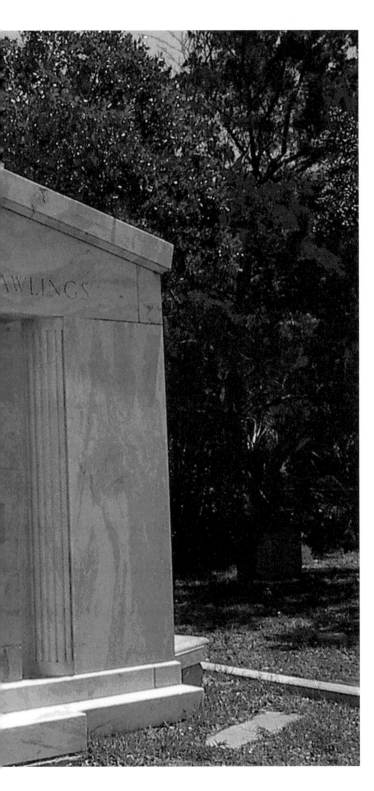

Adler Rawlings's mausoleum. *Courtesy of Dusty Smith.*

Some locals claim to have seen the shadowy form of a headless man walking down the street where the golf game was played that night. All of those who experience this phenomenon believe that it is the spirit of Dr. Rawlings, and that he is still seeking out his missing skull.

It is also said that if you visit the area on Auditorium Boulevard just below Dr. Rawlings's mausoleum on cold winter nights just before Christmas, you can hear a muffled voice coming from the mausoleum saying, "Fore!"

2

The Eternal Bride-to-Be

Listen close and listen well,
of a tale I shall now tell,
of a girl, a maiden fair,
that got a raw deal!

Pinewood Cemetery was originally part of the homestead purchased by James W. Smith in 1853. Smith originally named this portion of his land "Memento." He intended to give Memento to his daughter, Alena Beatrice, on her wedding day as a symbol of his love, pride and joy for his little girl. Little did he know how important this plot of land would soon become.

Alena was a beautiful girl with good family values. Her father wanted only the best for his little girl. Many of the local young men vied for Alena's attention. Alena, as some women will do, sought out a suitor who reminded her of her father. Since daddy was about to hand her 4.5 acres of property when she married, potential suitors in the area had a hard time filling these shoes. She wanted to marry a man who could love her the way she would love him.

As Alena came into womanhood, she dreamed of which of the young men would be her groom. She often spoke of how wonderful her wedding day would be. She described in detail the exact wedding dress she would make and wear on her special day. She knew how many buttons she wanted on the sleeves and how many petals she wanted on the lace roses on the bodice of the dress. She even knew how many ribs she wanted in her corset and how many feathers were to be fashioned into her garter.

Alena knew that Memento would eventually become hers once she married. She spent many long days walking the grounds deciding

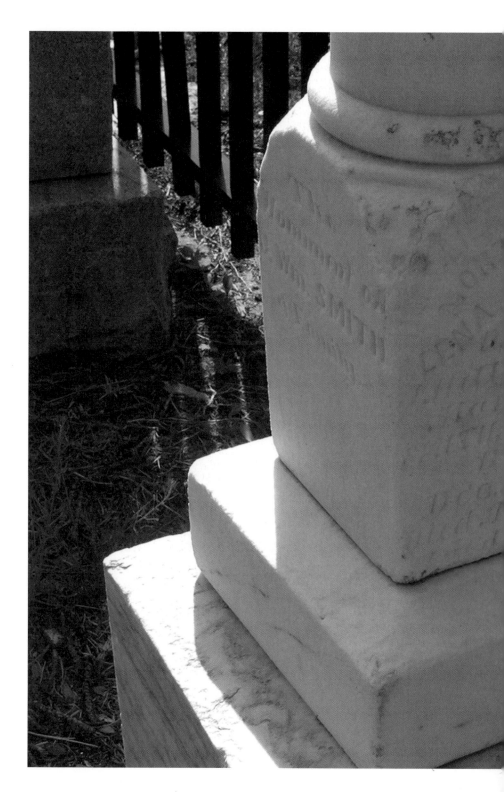

Alena Smith's
headstone.
*Courtesy of
Dusty Smith.*

where her home would be built and where she wanted her barns and stables. She even mapped out a location for her wedding day ceremony on the grounds.

Alena's mother, Margaret, often discussed with family friends that her daughter's one true desire in life was to marry. Having a husband and a family was Alena's dream of dreams. Sadly, it was not to be. Alena contracted smallpox. She knew that she would not survive and that all of her hopes and dreams of marriage were shattered. Alena had planned her big day from her earliest memory, only to have that dream ripped away. Lying in pain on her deathbed, visions of a bridal gown were still in her head, and she hoped against hope for a miracle.

Alena's dreams were stolen from her by fate, as if by a thief in the night. She died on April 15, 1877, and was laid to rest at the young age of nineteen. She holds the distinct honor of being the first person buried in Pinewood Cemetery.

Her father was heartbroken. He mourned her passing and visited her grave daily until his own passing on August 18, 1898. James missed Alena so much that he wouldn't allow anyone else to visit with her in what then became the Smith Family Burial Grounds.

Locals and people brave enough to pass by Pinewood Cemetery on the anniversary of Alena's death claim to have seen a beautiful young girl, in a long, flowing white bridal gown, walking through the upper level of the grounds. You may be lucky enough to catch a glimpse, too. But be careful. Do not speak of weddings or bridal gowns when you are near Alena's gravesite…she may try to steal your dreams away, too!

3

The Real McCoy

One of the most entrepreneurial characters to live in the Daytona Beach area was the dashing Bill McCoy, the famous rumrunner and "King of Rum Row." Bill achieved this royal status by being an honest businessman who always delivered his goods on time.

Bill was six-foot-two with broad shoulders, a slim waist, a booming deep voice, tanned face and eyes steady from years of gazing over the waters. He was born in Syracuse, New York, and was a cadet for two years on the *Saratoga*.

In 1890, Bill moved to Florida with his family, and he and his brother, Ben, became boat builders on the banks of the Halifax River, in Holly Hill, just outside of Daytona Beach.

Their boat, the *Uncle Sam*, which they built in 1903, was used as an excursion boat on the Tomoka River. Day cruises have always been a popular pastime in the area. Even Annie Oakley, famous sharpshooter, took an excursion trip upriver to shoot alligators when she was a guest at the Ormond Hotel.

The McCoy brothers built several more boats, including the *Republic*, built for Fred Vanderbilt in 1915 and the *Beachcomber* and the *Hibiscus*, built for John Wannamaker in 1918.

In 1920, the boat-building business was poor. A ship owner offered Bill a large salary to captain his boat and run rum. Bill declined the offer. However, he and his brother decided to go into the rumrunning business for themselves.

Bill purchased the *Henry Marshall* in Massachusetts. It was a ninety-foot fishing schooner built of white oak. The boat could carry 1,500 cases of liquor in wooden crates, or 3,000 cases in burlap bags. Bill sold all of his

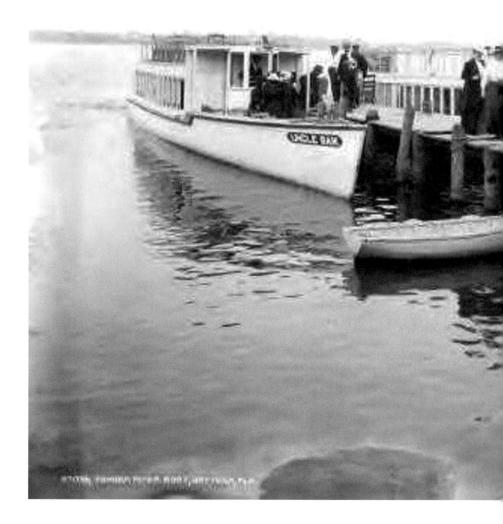

The *Uncle Sam. Courtesy of
the State Archives of Florida.*

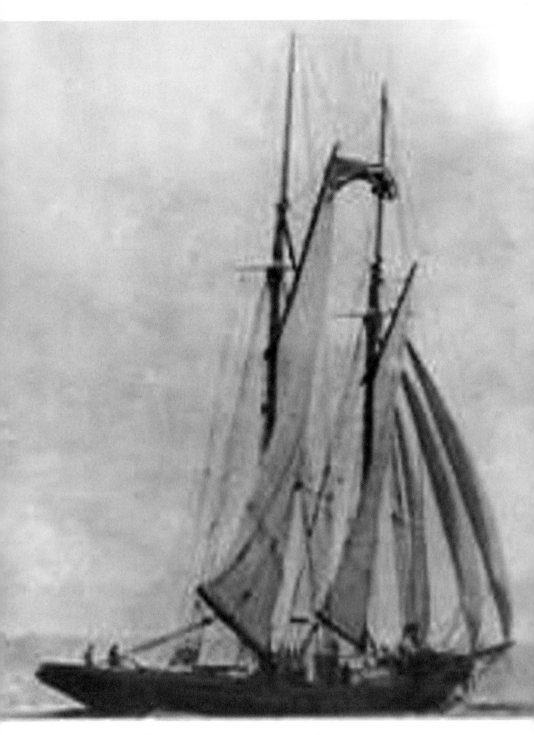

The *Arethusa. Courtesy of State Archives of Florida.*

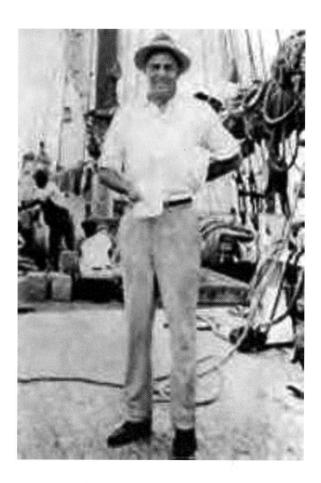

Bill McCoy. *Courtesy of State Archives of Florida.*

first cargo in the Hudson River Valley area of New York. This was the largest cargo brought into New York until that time. This feat is what earned Bill the title of "King of Rum Row."

With the money he made from that first sale of rum, Bill purchased the love of his life, a beautiful fishing schooner that Bill named the *Arethusa*.

Nassau, in the Bahamas, became Bill's home port for the next four years, and the *Arethusa* sailed many times from there loaded with liquor headed for Rum Row. Bill claimed that he successfully landed more than 170,000 cases of the illegal elixir during his rumrunning days.

During these days of running rum, some of the folks in the business were less than reputable. Rumrunning was the most profitable enterprise of that time, and every Tom, Dick and Harry was trying to cash in on the high demand for the intoxicating liquid. Many of these entrepreneurs had more of a taste for cash than rum and began to water down their hooch to increase profit margins. Bill and the boys wouldn't hear of this, so the

quality assurance question of the day quickly became, "Is that the real McCoy"?

The coast guard closely watched the McCoy operation, and the clever Bill renamed his beloved ship the *Tomoka* and placed her under the Bahamian registry. He also named her the *Marie Celeste* and registered her with the French. Eventually, in 1921, the Revenue Service took the *Henry Marshall* into custody when its drunken captain went ashore and left the ship in the hands of an incompetent shipmate. Revenue agents boarded the *Tomoka*, but Bill claimed he was beyond the three-mile limit and tried to make a run for freedom with some of the revenue agents still on board. The *Tomoka* led the coast guard on a merry chase until the coast guard cutter the *Seneca* fired on the *Tomoka*. Bill finally surrendered, so ending the rumrunning days of Bill McCoy and his 130-foot *Tomoka*.

On December 30, 1948, Bill died quietly aboard his boat the *Blue Lagoon* in Stuart, Florida, at the age of seventy-one.

Many of the McCoy family are current residents of Pinewood Cemetery, although not all of the headstones hold the famous family name. They got too involved in illegal ventures over the years and they picked up Bill's name-changing habit, which he had used with his boats, and made use of this practice with their own personal names. So, after thirty or forty years of switching their names around, not even their own family members could remember whose name was originally what. They were just buried with whatever name they happened to be using at the time of their death.

Some of the locals who live along the Tomoka and Halifax Rivers say that on certain nights you can hear drunken laughter, people cheering and toasting one another, the clinking of glasses and an occasional loud gunshot. It is also said that on nights when the moonlight is just right, you can see Bill's beloved *Arethusa* heading north in the channel, still being chased by the *Seneca*.

4

Old Bikers Never Die—They Haunt the Boot Hill Saloon

One of the most famous haunts of Daytona Beach is the world-famous Boot Hill Saloon.

The official deeds and abstracts on the building go back to the 1800s. When the building was originally built it was actually three businesses in one. The east side of the building was a cigar and barber shop, the center section a watering hole (better known as a bar) and the west section was the local church. In fact, if you look around the Boot Hill Saloon, you can still see the old church pew on the side where the original church was.

The tavern was originally called the Kit Kat Club. It was one of the hottest spots in Daytona Beach in the early 1900s, when Daytona Beach was booming as a popular resort town.

The Kit Kat Club was considered a respectable place, and the owners were less than thrilled with the motorcycle racing on the beach, which was becoming increasingly popular in the mid-1930s. Drag racing of the motorcycles was spreading to the Main Street area, and the popular Kit Kat Club began closing during the season when the motorcycle races and the enthusiasts came to town.

The motorcycle races continued to grow, as did the number of enthusiasts, and the aging Kit Kat Club owners sold the bar to one of its bartenders, a man by the name of Dennis MaGuire. The bar was turned into a Western-themed bar called the Boot Hill Saloon.

The bar remained closed during the busy motorcycle racing season for a few years, even though Main Street was bustling with activity and bikers were everywhere.

In the early 1970s, Bike Week, as it was loosely named, was gaining momentum and becoming a happening event, with several thousand bikers

Bikeweek parade on International Speedway Boulevard Bridge. *Courtesy State Archives of Florida.*

converging on Daytona Beach in the early spring. Main Street became the center of the activities, as the beach hotels provided accommodations for the events that took place on the beach. Dennis MaGuire was more biker-friendly than the previous owners, and he began to keep the bar open during these events.

The Boot Hill Saloon became a popular meeting place for the bikers to gather when they arrived in town. Word spread and the bar rapidly became the place to be during Bike Week, as well as throughout the rest of the year. "Friendly people, cold beer and good times" became the motto of the saloon. It is the kind of place that makes you feel right at home, even if you are a stranger in town.

Walking into the Boot Hill Saloon makes you feel as though you are taking a trip into the past. Seeing all of the memorabilia left behind on the walls, ceiling, tables and bar will keep you intrigued for hours. Signatures of the multitudes of people who have visited over the years remain on every surface. Business cards, photographs of great times and personal items—including ladies' undergarments—and other marks of the many visitors are hung on every hook and nail. Ornate chandeliers from an earlier era, some boasting cobwebs, hang from the ceiling. A walk around the Boot Hill Saloon is a true window into the biker lifestyle and the past.

As a favorite haunt of many over the years, and with its rich and colorful history, it's no wonder that the world-famous Boot Hill Saloon has its fair share of spirit activity.

We can't be quite sure just who the spirits are, but we do know they are here. Employees of "the Boot," as they casually call it, have heard footsteps, felt cold spots and heard people talking—all when the bar was empty of customers. One toilet in the men's room actually flushes by itself—which is not such a bad thing. One of the faucets in the ladies' room turns on and off by itself. One of the cooler doors has been known to open overnight. Pool balls roll across the pool table by themselves. Songs begin to play on the jukebox when it's unplugged, bowls of peanuts move across the bar top and the manager's keys have been known to travel from one end of the bar to the other when he is the only one inside the bar and the doors are locked.

As the saying goes, "Order a drink and have a seat; you're better off here than across the street"—across the street being Pinewood Cemetery!

5

Booze Alley—Prohibition's Contribution to the Afterlife

During Prohibition, Daytona Beach proudly boasted of having no saloons, but that didn't mean that booze wasn't readily available. Moonshiners and rumrunners were a large part of the Florida economy at that time. Locals and tourists alike had no trouble finding "the good stuff" right downtown.

Directly across from the Halifax River Yacht Club is a small alley that runs from Beach Street to Palmetto Avenue. It is named Cottage Lane, and during Prohibition it was affectionately called "Booze Alley." This little street housed three prosperous speakeasies, and for a price you could get anything you wanted.

On occasion, upstanding citizens were known to take a nip or two. Sometimes those upstanding citizens drank more than a nip or two, and were no longer standing. One such person actually wrapped his Model T around a palmetto palm. Some local boys saw the vehicle weaving down the street when it suddenly veered and hit the tree. When the boys checked on the man, they discovered that he was completely unharmed. When he sat up in the car he yelled to one of the boys to "crank it up!" The boy replied, "Sorry, this car is past cranking," as he pointed to the axle that was now bent around the tree.

Some believe the popularity of owning a speakeasy, running rum or moonshining may have been the true beginnings of stock car racing. Many transporters of the liquid lightning had to learn how to beef up their vehicles to stay ahead of the law. They had to learn to drive under a great deal of pressure—and at very high speeds. They also learned that adding an extra leaf spring—which gave added support to the vehicle when it was transporting a heavy load—smoothed out the ride. When a

vehicle was empty, the back end of the car stuck up high and thus was easy for the law to spot.

Moonshiners often gave themselves away at the local general store. Anyone purchasing large quantities of sugar was immediately called in. Since many producers of the illegal elixir needed four to five hundred pounds of sugar at a time, most store owners or clerks were certain that it wasn't going to be used to make jam or cakes.

One such purchaser picked up smaller loads of sugar at several stores all day, until he had the required amount. When he made it back to his still and began cooking up the batch, he thought he was home free. Not true! Several days later he was approached by one of his neighbors. It seems that when the man dumped the corn mash out on the creek bank, his neighbors' cows had a wild time eating it up. The cows also got very drunk. Several of the cows died from the amount of alcohol they had consumed. That particular still never operated again. Whether the spirits of those cows remain in that field is something we may never know.

These were exhilarating times in the area. From the wealthiest to the poorest residents of the area, no one was above hauling in, making, distributing or drinking the illegal liquid.

These were also confusing times. Often, it was hard to tell which side the law was on. With so many drop-off points for liquor along the banks of the Halifax River, all too often the officer who was supposed to be turning in the illegal booze was actually taking it home with him in the trunk of his vehicle.

In later years, one of these not-so-lawful lawmen became as high up as a judge. Judge Beard was a bit unconventional before and after he took the bench. He was always seen around town with his faithful dog, Pepper. Pepper was a solid-black husky that enjoyed being out on the town with the judge.

Judge Beard drove around town wearing a broad-brimmed hat and smoking a big cigar, with Pepper at his side in the passenger seat. Pepper even attended court with the judge. He talked to Pepper constantly, and was known to ask the dog whether an accused party was guilty or not. It is said that if the dog growled, Judge Beard pronounced the poor soul guilty. Some locals even thought that the judge wasn't above kicking Pepper to get the verdict he desired.

During one case, two young men were arguing over the ownership of a bicycle. The judge sent an officer to the hardware store to get a hacksaw. His verdict was to saw the bike in half and give each of the young men half of the bike so they wouldn't argue anymore.

During Prohibition, the judge became a regular fixture at one of the

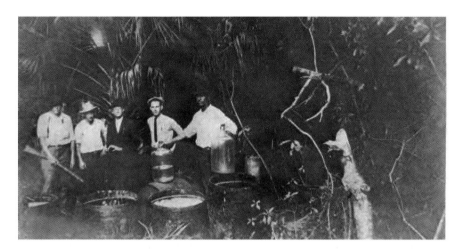

Confiscated still. *Courtesy of State Archives of Florida.*

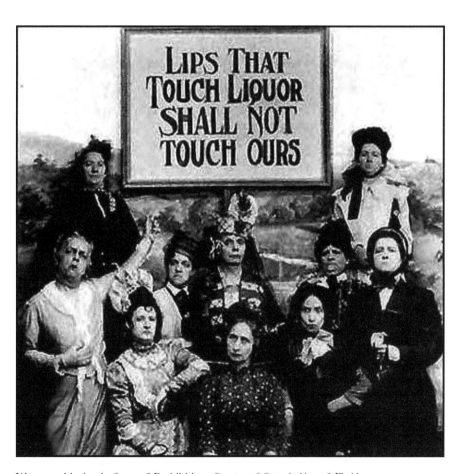

Women with sign in favor of Prohibition. *Courtesy of State Archives of Florida.*

speakeasies located on Booze Alley. This habit didn't end when he took the bench. Although booze was once again legal, the judge tipped the bottle back more than most in town.

After Judge Beard retired, someone meted out his own brand of justice on the judge. He was beaten to death in his home one night as he slept. His faithful dog, Pepper, was shot in the head.

Pepper may still frequent some of the local courthouses. Nighttime security guards on nightly rounds through the courthouse have said that they hear a dog growling as they pass by Judge Beard's old chambers or courtroom. Some defendants have reported hearing this same growling as guilty verdicts are read in what used to be Judge Beard's courtroom. Many have seen the judge wearing his broad-brimmed hat and smoking a big cigar. He is either walking down Booze Alley or sitting on one of the benches in Riverfront Park, near the courthouse. The judge is always accompanied by the dark form of a furry dog right by his side.

6

Daytona's Great Benefactors

Commodore and Mary Burgoyne's spirits may still linger here in Daytona Beach, along the Halifax River. The Commodore—or Charles, as he was better known—moved to the Daytona Beach area in 1896. Charles Grover Burgoyne was born in Fairmont, Virginia, in 1847. He served in the army during the Civil War, joining at age fourteen. He eventually became known as "the father of tourism" for Daytona Beach.

At age twenty-eight, Charles went to New York and opened up a printing company. After earning a fortune there, he moved to Florida with his third wife, young Mary Therese MacCauley, who was a proofreader at his printing company. Mary was only sixteen years old—twenty-eight years his junior—when she married Charles.

Charles became one of Daytona's most noteworthy benefactors. He held concerts in the park, was the president of the East Coast Auto Association, sponsored the Elks Lodge, built the Burgoyne Casino and Esplanade, helped to establish the Daytona Theater, held the office of mayor for two separate terms and was the commodore of the Halifax River Yacht Club for many years. The Halifax River Yacht Club is the oldest yacht club in the United States that remains in its original location. Built in 1896, the yacht club has been the host to many famous people from around the world—and their vessels.

The commodore built the Burgoyne Casino, on City Island, in 1915 and presented it as a gift to the City of Daytona Beach. The Burgoyne Casino sat directly across the water from the yacht club and was not really a casino at all; it was a busy community center. It originally served as the chamber of commerce, as well as a recreation facility where locals could participate in shuffleboard, cards, horseshoes or checkers, or even attend

The Elks Lodge. *Courtesy of State Archives of Florida.*

East Coast Auto Club building. *Courtesy of State Archives of Florida.*

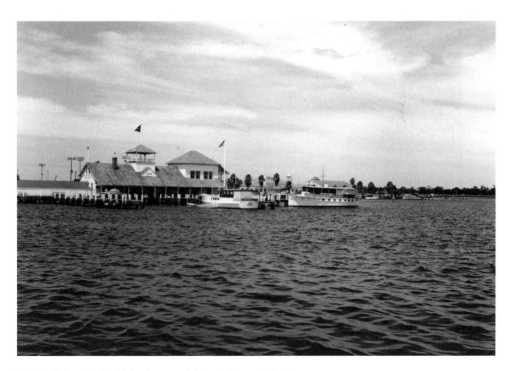

Halifax River Yacht Club. *Courtesy of State Archives of Florida.*

a dance. The seventeen-thousand-square-foot structure also housed the symphony or orchestra members who played in the esplanade in the winter. In 1937, the Burgoyne Casino burned to the ground under very mysterious circumstances and was never rebuilt.

In 1914, in an effort to improve the downtown Beach Street area, Charles commissioned a ten-foot-wide promenade that wound its way along the banks of the Halifax River, extending from Orange Avenue to Bay Street. The promenade was bordered by a rock seawall and lined with streetlights. Each pole was adorned with a cluster of five large white globes. Locals and tourists alike enjoyed leisurely walks along the pathways. The commodore shared his love of music with the public by building a round gazebo at the corner of Orange Avenue and Beach Street and hired Saracina's Royal Italian Band, from New York, to play there during the winter. It was named the Esplanade de Burgoyne, and a bronze plaque honoring Charles was donated by the City.

Some of the spirits that can be found in Riverfront Park may be tourists who once visited that very spot. It is widely believed that spirits return to areas where they were happy, comfortable or enjoyed good times. Since there have been so many visitors to the esplanade area, there is no way to determine the identities of the spirits who now reside in the esplanade, which is now named Riverfront Park.

The theory of spirits being linked back to places they enjoyed when they were still among the living may be why this area has so much ghostly activity. Before Daytona Beach became popular for motorcycles and auto racing, it was the vacation destination for the social elite of the era. Some of these folks may still be enjoying the winding pathways of the esplanade or playing a game of shuffleboard over on City Island.

After Charles made his mark on the area, he and his wife, Mary, built one of the largest homes ever to adorn the downtown Daytona Beach Street area. Charles purchased an entire square block downtown between Bay and International Speedway Boulevard and Beach and Palmetto Streets. He built his ornate three-story mansion that became the showplace of the area.

Known as "the castle" by many locals, the house was completely surrounded by a stone wall. It boasted a separate kitchen house, its own water tower, a greenhouse and a boat dock and large boathouse, where their sixty-five-foot yacht was anchored. In 1912, Charles had a twenty-five-thousand-dollar Aeolian pipe organ installed in his home. He played the organ for his friends and associates at music recitals held in his music room. Unfortunately, the castle was torn down in 1941 to make room for a shopping center.

The Burgoyne Casino. *Courtesy of State Archives of Florida.*

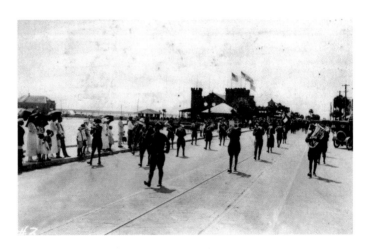

Saracina's Royal Italian Band from New York marching down the Esplanade de Burgoyne, with the Burgoyne Casino in the background. *Courtesy of State Archives of Florida.*

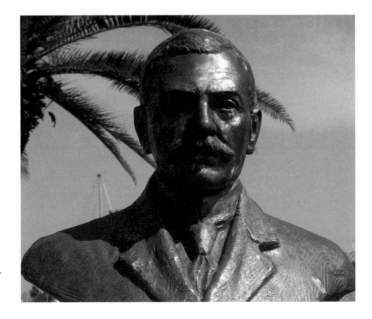

Bust of Charles Burgoyne in Riverfront Park. *Courtesy of Dusty Smith.*

"The Castle," home of Charles and Mary Burgoyne. *Courtesy of State Archives of Florida.*

The Burgoynes had no children of their own, and so were very generous to the children of the area, providing milk for schoolchildren and aiding the needy in whatever ways they could. Mrs. Burgoyne gave young girls of the city pearl necklaces for their birthdays, and a huge party was provided for the children every year on the lawn of their home.

When Commodore Burgoyne married his sweetheart, Mary, he purchased the large yacht and it was christened the *Sweetheart*, after his beloved Mary. The *Sweetheart* was the sleekest ship on the Halifax River.

On holidays the yacht was adorned with flags and banners and local residents were invited along for boat rides down the river. The commodore even had the channel dredged in the river for better access while sailing their yacht. Charles and Mary spent a great deal of time aboard the *Sweetheart*, alone and with many guests. Mary adored Charles and the ship that he so lovingly named for her.

Charles passed from this world in 1916. Mary had a beautiful monument built in Pinewood Cemetery for her beloved—a monument befitting the man she loved and now hopelessly missed. She imported Italian marble for the archway and a six-foot marble angel to watch over her departed

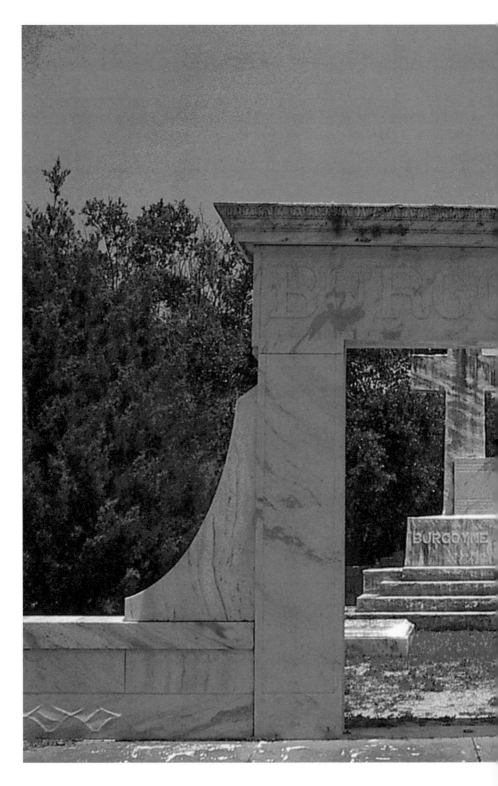

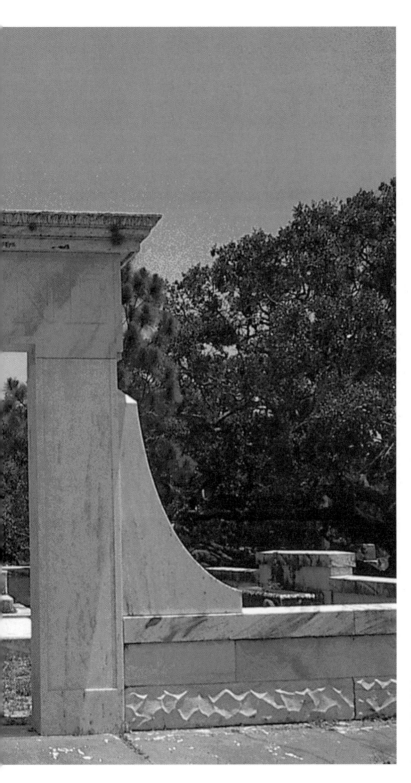

Burgoyne
Monument
in Pinewood
Cemetery.
*Courtesy of
Dusty Smith.*

husband. She designed ornate brass gates for the entryway and placed benches for visiting with her lost love.

Out of grief and respect for her departed love, from the time Charles passed away until her own death in 1948, Mary wore a black veil that covered her face. From 1916 until her passing, the only people to see Mary's face were her faithful servant and her private physician. Many rumors circulated in town as to why she wore this veil, but the simple truth was that she did it in respectful mourning of the loss of her husband.

Mary's spirit is very active in the Daytona Beach area. Not only is she seen during daytime and nighttime hours inside the beautiful monument she had built for her husband, but she can be seen walking the dirt driveways of Pinewood Cemetery, carrying large bundles of flowers.

Mary's ghostly form can also be seen walking from where the old kitchen house of their home once stood to the Daytona School, a trip she made often to deliver trays of nutritious food to the schoolchildren when she was alive.

One of the ghost ships that has been seen on the Halifax River is the *Sweetheart*, once owned by the Burgoynes. The *Sweetheart* is always accompanied by the spirit of Mary.

The strong emotional bond between Charles and Mary may be why Mary's spirit can still be seen in the area and seen boarding the yacht. There have been many reports of the misty figure of a woman wandering along the shoreline that once was the residence of the Burgoynes. The figure then glides above the waters of the Halifax River as if it is following the long gone path of the boat dock where the *Sweetheart* was once anchored. As the misty figure nears the end of what once was the dock, an eerie fog-like ship can suddenly be seen. As the ghostly woman steps onto the deck, the two disappear into the night.

7
The Man Who Lost His Head—Twice!

Dan Sawyer once worked at the local sawmill in the early 1900s. He had worked at the mill for many, many years and was very experienced. One day, completely by accident, Dan Sawyer slipped and fell into one of the whirling saw blades.

It all happened so fast that Dan Sawyer didn't even have time to scream for help. The saw blades cut his head clean off!

The undertaker came to collect Dan—or at least, his pieces—and prepare him for his burial. Since Dan Sawyer was a longtime resident and was known throughout the community, there would be a viewing. The undertaker saw this as a bit of a challenge, since Dan Sawyer's head was no longer attached to his body. He didn't give up, though. The undertaker placed Dan's head back onto his body and arranged a high-collared shirt to hide the horrible details of Dan's gruesome death.

The gravedigger set about the task of digging the grave. The coffin maker, whose love of drinking made him careless in his work, began making Dan Sawyer's casket. During this time it was common to stand empty beer bottles inside the coffin to make the satin lining appear ruffled.

There was a beautiful horse-drawn hearse and six pallbearers. Nearly the entire town joined in the funeral procession. It was a funeral to die for! The horse-drawn hearse was followed closely by Dan Sawyer's loyal and loving wife. She held her head high as she walked behind her departed husband.

Just before the hearse was to take the final turn into Pinewood Cemetery, something spooked the horse. It reared back, jumped forward and bolted ahead. As it did, Dan Sawyer's coffin slid out the rear of the hearse. The

commotion was just enough to loosen some of the poorly placed coffin nails. The sides of the coffin fell away and Dan Sawyer's body fell onto the street. The satin lining came apart and beer bottles rolled. Dan's body fell one way and his head rolled another way! His wife screamed. The crowd gasped in horror.

The undertaker hastily repaired the coffin and quickly placed Dan Sawyer's remains back inside. At such an awkward moment, the undertaker was not concerned with the correct placement of Dan Sawyer's head. He only cared about removing the remains from the street and from the crowd's view.

Dan Sawyer was finally laid to rest—or at least that is what the townspeople thought. There are those who say that if you pass by Dan Sawyer's grave on moonless nights, you can hear the sound of bottles rattling. They say it is the spirit of Dan Sawyer trying to put his head back on straight!

8

Encounter at the Green Lantern

For most people in cities and towns across America and the rest of the world, World War II changed their lives. Life in Daytona Beach also changed from what the residents once knew. The Daytona Boatworks held many launching ceremonies for U.S. Naval subchasers from its production facility docks.

On December 15, 1942, the Daytona Beach Naval Air Station was converted into the World War II Naval Air Training Center, where thousands of young men were trained to serve their country.

At Bethune Point, off South Beach Street, a women's army corps tent city was used as quarters for six thousand women until more permanent housing was built. The training center of the Second Women's Army Corps, or WAC, was located where Halifax Medical Center and Daytona Beach Community College now stand.

Daytona Beach was chosen because of its year-round mild climate. At the peak of its operation, the cantonment housed and trained over fourteen thousand women.

From 1942 to 1944, the companies of the Second WAC marched on the boardwalk on Saturday mornings for reviews. This proved to be popular with the locals as well as the soldiers and sailors from nearby bases.

One of the young WACs, Annie, was not only lucky enough to be stationed in beautiful Daytona Beach, but would also be lucky enough to meet Joe and fall in love with him. Joe was stationed at the naval training facility, training to be a pilot.

One Saturday morning, as the WACs were marching in their review on the boardwalk, Joe happened to be flying training maneuvers over the beach. Part of the training exercise was to come in low over the beach and

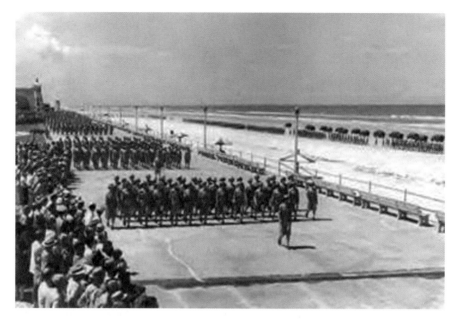

WAC's parade on Daytona Boardwalk. *Courtesy of State Archives of Florida.*

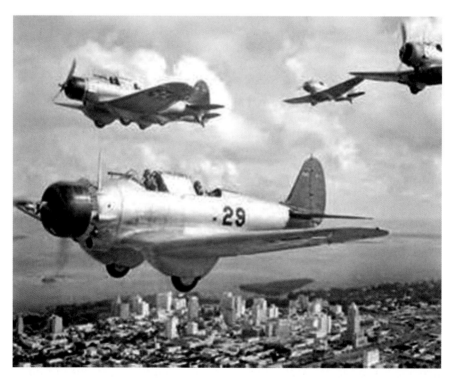

Naval flight over Florida. *Courtesy of State Archives of Florida.*

head straight out to the airfield. This particular exercise was of interest to many of the local residents, especially those who lived along the beach. Not only were they awakened in the early morning hours by the loud noise, they actually had to black out the windows of their homes that faced the ocean, just in case the enemy might be lurking just offshore somewhere in the waters of the Atlantic.

As Joe eased his plane in over the beach that morning, he came in low enough to see the WAC review just finishing up on the boardwalk. He noticed the people below him all looking skyward and pointing at the awesome sight of the training flight. One person stood out to him just a bit more than any of the others. A fair-skinned, redheaded woman in uniform was the only person who actually saluted as Joe's plane flew over the boardwalk. He couldn't really see the details of her face, but her respect stood out. Joe smiled to himself as he thought that someday he would enjoy nothing more than to be with a woman like that—beautiful, from what he could tell, and respectful.

During this time, the Green Lantern Tavern was a popular nightspot for servicemen and women. It was located on International Speedway Boulevard, just west of Beach Street.

One night, Joe and some other flight trainees decided to go and relax at the Green Lantern. Joe wasn't really a drinking man, so he watched his friends toss back a few cold beers as he quietly sipped on a Coke. His thoughts turned to the woman who had saluted him. As he focused his thoughts on who she might be and wondered if he would ever be lucky enough to meet her, the door to the tavern opened and there she stood, the fair-skinned redhead. His mouth dropped open, and he found himself staring at the young woman in the doorway. He regained his composure long enough to ask the bartender to get her whatever she wanted, on him.

Annie ordered a Coke, just like Joe, and walked over to him to thank him for purchasing it for her. But before she could utter a word, Joe said, "I saw you salute me this morning. Thank you." Annie was a bit shocked. She told Joe that she respected anyone who was fighting or working in the war effort, but pilots most of all. She then thanked him for the Coke. Joe asked if she cared to sit at a table and talk with him for a while. Annie graciously accepted Joe's offer.

The couple found a small table near the back of the tavern. They talked for hours. As they spoke and got to know one another, Joe pulled out his pocketknife and carved a small notch under the table. When Annie saw that Joe was a bit distracted, she asked him what he was doing. He told her that he was marking this table as theirs. If he were ever lucky enough

to be able to sit with her at this same table again, he would put another notch in it. Annie smiled at Joe with approval.

When the tavern closed, Joe and Annie walked the rest of the night away in the downtown area. By sunrise, they had fallen deeply in love. They agreed to meet back at the Green Lantern Tavern every chance they could.

For several weeks, Annie and Joe met as frequently as they could. They always sat at the same table in the Green Lantern, and every time, Joe carved another notch under their table. One night when the young couple was to meet, Joe wound up sitting at their table alone, all night long. Joe couldn't imagine what had happened to his dear Annie. Thoughts raced through his head all night. Did she get called to extra duties? Was she held up by a surprise inspection? Was she aiding an ill friend?

The following morning, Joe couldn't stand not knowing any longer. He made his way to the WAC barracks to find out what had become of his love. With all the secrecy surrounding any information during World War II, finding out where enlisted personnel were was not an easy task. Joe managed to get lucky, though. As he inquired about Annie's whereabouts with the duty officer, one of Annie's friends overheard the conversation. She waited for Joe to be denied information and motioned for him to come to her. She explained to Joe that Annie had been shipped out. There was no notice given until moments before she had to leave. Joe was devastated. He thanked the woman for the information and went back to the training base.

For months Joe waited to get a letter, a note—something, anything—from his dear Annie. No word ever came. Joe fell into a heartbroken depression and was never the same. He was never called into active duty, and the war ended. Joe could not revel in the happy atmosphere like other Americans; he still had no word of his Annie.

Joe remained in the Daytona Beach area and kept up with names and locations of many of the friends he had made during the war. One day he finally ran across an obscure article about a transport that had suffered engine trouble. The transport plane went into a spin after the engines failed, and it didn't recover. As Joe continued to read this nondescript report, a name suddenly glared out at him. It was his Annie! She had been on the flight. She died the same night she left Daytona.

Joe never married; he carried his love and loss of Annie with him for many years. Most residents who knew Joe said he was a heartbroken man with no hope, until one day when Joe was walking along Beach Street on his way to the bank. He noticed a small table in the window of a secondhand store. He rushed into the store and began asking where they

had gotten the table. The store clerk had no idea where it had come from, only that it was now there—and for sale, cheap. As the clerk spoke, Joe reached up under the table. Sure enough, there were the notches. It was Joe and Annie's table! Joe immediately paid the clerk for the small table and whisked it out the door. Joe may have lost his Annie, but he regained his hope by finding the table where he and Annie had sat and shared so many wonderful moments.

Many locals believe that Annie's spirit may have found its way back, as well. Joe set the table up near the front window of his small apartment. As people walked by, they saw Joe sitting at the small table, holding intimate conversations with no one that they could see—someone Joe always referred to as Annie.

9

Ghosts of Gangsters

Many people are unaware that many gangsters of the twenties and thirties owned businesses and homes here in the central Florida area. They came here to get away from the workaday world of the North, lay down their Tommy guns and do a bit of relaxing in the sun. Well, most of them.

Some of the more notable gangsters seen in the Daytona Beach area include the Barker gang, John Dillinger, the Ashley gang, Lester J. Gillis (a.k.a. Baby Face Nelson) and the most notorious of the group, Al Capone.

The peaceful atmosphere, lovely weather and ability to blend in with the tourists is probably what attracted most of them to the area. Also, there was a land boom at that time, so inexpensive places to hide out were easy to come by.

With all the rumrunners, cotton gins and stills cropping up, northern gangsters drew little—if any—attention to themselves as long as they didn't rob banks, shoot up the speakeasies or engage in any other illegal activities while soaking up some sunshine.

The Ashley gang gained their reputation by running rum in southern Florida. When things got too hot, they headed for their hideout near Lake Okeechobee. The entire gang was eventually gunned down near the community of Micco. Apparently they hadn't read the rule in the gangster's rulebook that states, "Do not draw undo attention to yourself while lying low."

John Dillinger must have missed that rule as well. He chose the Daytona Beach area as an occasional retreat from the law. Many stories circulated around town about the infamous Dillinger. He never robbed any banks in

the area but did show his true nature on the beach from time to time. He was seen pulling out his machine gun and shooting a porpoise just for fun. It was a senseless act that brought more shame to his character than any of his bank robberies could.

Baby Face Nelson must have read the complete gangster's rulebook. The only mention of him locally involves the occasional arguments he became involved in after having a bit too much to drink.

The Barker gang started out as farmers in Indiana. They became bank robbers to offset their meager income. The money was good, but the fringe benefits eventually cost them their lives. The Barker gang terrorized the area between Indianapolis and Chicago. Ma Barker had four sons—Herman, Arthur (a.k.a. "Doc"), Fred and Lloyd. Lloyd was the loner of her sons. The other three became known for their brutal natures.

When their illegal activities attracted too much attention up north, Ma packed up the boys and headed south. She rented a two-story wood-frame house for them to hide out in. The house was in the town of Lake Weir. Ma Barker was no dummy. To stay on the good side of the folks in the community, she made some hefty donations to the local churches and school. The gang was careful not to involve themselves in any illegal activities, and they outwardly presented themselves as upstanding pillars of the community. It was a good cover for the barbaric nature of the Barker family.

The FBI was given an anonymous tip that led to the location of the Barkers, and the sounds of the bloody shootout that ensued could be heard for miles. Ma and her son Fred were killed during the shootout. Doc was captured, and Herman escaped the scene. News of the bloody confrontation spread like wildfire. Some residents of Daytona Beach, who were out hunting deer at the time, decided to make the short trip to Lake Weir to see what they could. After all, deer were plentiful at that time; notorious gangsters were not.

When they arrived, the house proved a curiosity. It was riddled with bullet holes, but other than that there wasn't much to see. However, the local funeral home was the place to be. The urge to be able to make the claim that you had seen one of the notorious Barker gang—dead or alive—must have been very strong, indeed. The line to view the two bodies went around the block.

One of the onlookers noted the eeriness of the bodies—not because they were grotesque, but because Ma and Fred looked like twin brothers. They were the same size and stature. If both were dressed as men, no one would have been able to tell the two apart.

Doc was later killed while trying to escape from Alcatraz. Herman chose to take his own life with a bullet when cornered by the police in Kansas.

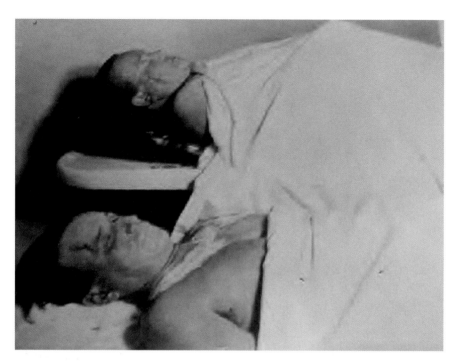

Ma and Fred Barker's corpses. *Courtesy of State Archives of Florida.*

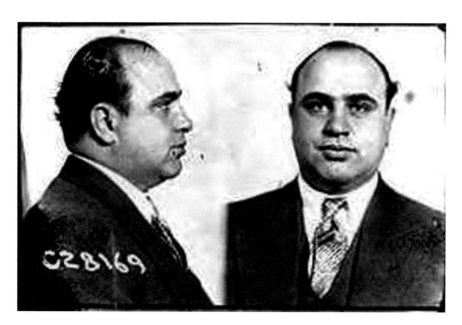

Al Capone. *Courtesy of State Archives of Florida.*

Al Capone proved one of the more respectable gangsters to frequent the Daytona Beach area. He owned many properties throughout the state, but Daytona seems to have been his best-kept secret hideout.

One of the taverns he owned at a very profitable time is now known as one of the finest gourmet restaurants in Daytona Beach. Chez Paul's Italian and French cuisine attracts only the finest palates through its doors, an interesting change from the days when Al owned the speakeasy-style tavern.

Another property once reportedly owned by Capone boasts a secret underground exit. The long, narrow passageway that leads from the house to the Halifax River was used by certain acquaintances of Mr. Capone's to evade authorities. At the end of the long passageway, a small boat with a quiet motor awaited its passengers. No one is quite sure who or how many people used this inventive getaway.

It is said that booze and other illegal items of the day were also transported in and out of the house through this passageway. This particular house is still in the family—not the crime family, but the bloodline of Capone. A descendent now owns the home and has opened it up as an art studio, where he donates his time and talent to teach local children about art and drawing.

One of the houses Capone reportedly purchased is said to still be occupied by one of Al's mistresses. The young woman took her own life shortly after hearing of her lover's legal troubles.

The current owner of the property reports that perfume can be smelled every night in the master bedroom of the home, a room that she and Capone shared when he was in town. When the gentleman who now owns the home chooses to bring a woman back to his place, he finds out whose place it really is. The spirit of the woman in the house makes sure that any other woman soon feels so uncomfortable that she leaves the residence quickly, never to return.

The apparition of the young woman has been seen in the master bedroom, the kitchen and in the backyard. Local legend states that Capone buried some of his ill-gotten gains somewhere on the property, but he left no clues to its specific location. It is said that when the female spirit is seen in the backyard, she seems to be searching the grounds for something. Could her spirit hold the secret to finding some of Al Capone's lost fortune? We may never know.

No one can be sure just how many spirits associated with gangster activity from the past still hide out in the Daytona Beach area, but we do know that they are here—and are not as hidden as they once were.

10

The Guardian of the Garden

There may be many otherworldly residents in Riverfront Park. There is a small memorial and a rose garden there to remember one of Daytona Beach's most beloved gardeners. The inscription on the plaque reads, "Alys Clancy P.D.G. 'Guardian of Gardens,' plain dirt gardener."

Alys was not only one of the garden editors for the *Daytona News-Journal*, but also a very active member of the Volusia Garden Club and the Council of Garden Clubs of the Halifax District.

There is a gardening award with the local club named "the Alys Clancy Award," after her. She even ran the city's beautification department at one time, and she ran that department with an iron hand.

One of the workers in that department remembered when a local resident donated some palm trees to the city. Alys's coworker said that when he explained to her that the trees were too heavy and awkward to be placed where she insisted they be planted, Alys came back at him with a threat that would leave him without his job if he didn't immediately do as he was told. The man had had enough of Alys and her attitude. He placed blocks of wood under the tires of the truck so the heavy load wouldn't shift, turned off the ignition and walked away. He did not lose his job, and the mayor convinced Alys that the trees could be better used on the property of the City Island Courthouse. It took some doing, but Alys finally agreed, as long as she was given permission to plant some of her own award-winning Alys Clancy roses in Riverfront Park. The deal was made, and palm trees and roses were promptly planted.

The roses that surround her memorial are some of the plants she originally cultivated and planted in the park. One local resident remembers when Alys Clancy introduced her to special folks who had different-colored oleanders.

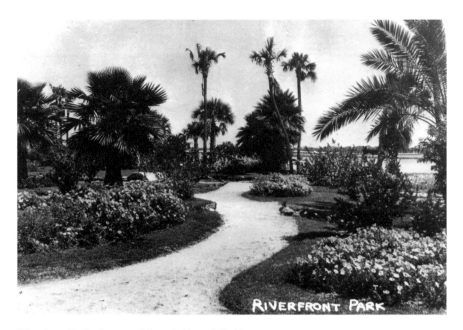

Riverfront Park. *Courtesy of State Archives of Florida.*

For several years, the Volusia Garden Club gave away cuttings from these plants. The last time they gave rooted cuttings was in Riverfront Park, and the line was two blocks long down Beach Street. Alys carried seven hundred rooted oleanders to give away to Daytona Beach locals interested in growing these hardy plants. She can be directly linked to many of the oleanders still growing throughout the Daytona Beach area today.

It may be her strong physical and emotional attachment to her roses and other plants that keeps Alys's spirit here by her roses and memorial.

Some of the current maintenance staff shared some interesting accounts of activity that may be directly associated with Alys and her love of gardening. When the First Coast Rose Society honored Alys by trying to plant someone else's award-winning roses in Alys's garden, the roses all died. No matter what the gardeners tried, the roses all withered and died. It seems that Alys was not pleased with being honored with someone else's apparently unworthy roses.

Alys was once quoted saying "October in Florida is like April in the North. It's a great time to get out and get busy." Many of the workers who tend to the daily gardening chores find that in October, if they don't stay busy, there are strange happenings around the areas that Alys had direct contact with when she was alive. It is still sometimes quite hot in October. If the workers take a few extra moments to cool down, Alys seems to show up and get them back to work.

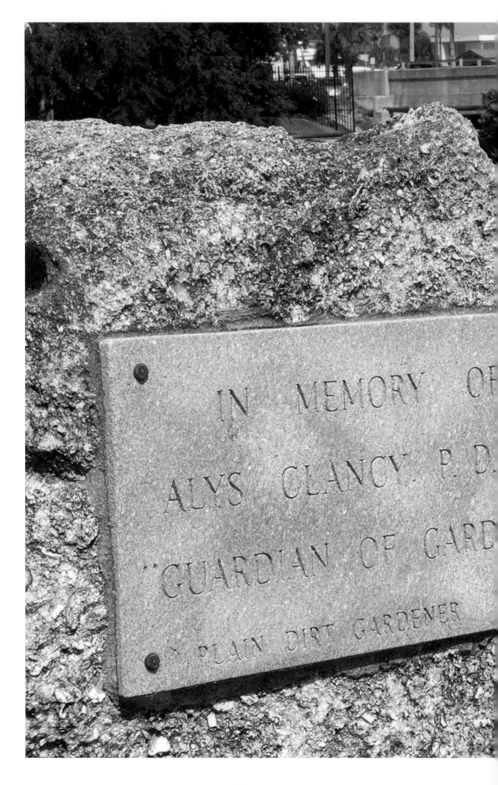

Alys Clancy's remembrance plaque in Riverfront Park, with her award-winning roses in the background. *Courtesy of Dusty Smith.*

One worker remembers taking a few extra minutes right next to Alys's memorial. When he turned to grab for the rake he left leaning against the stone, it had somehow been placed on the pathway and he stepped onto the metal end and got whacked in the face with the handle. Needless to say, this man never extended his break again. Could Alys have gotten upset with his lazy attitude and moved the rake onto the path? We may never know for sure.

Some say that Alys had a green thumb and a brown heart. Others say she gave much of herself to her community, including living memorials that still grow all over town. If you remember nothing else about Alys Clancy, remember this: don't get lazy in your garden, even if it's hot, because the spirit of Alys Clancy may be around to keep you Johnny-on-the-spot!

11

The Loss of a Local Treasure

Pinewood Cemetery is located on Main Street in Daytona Beach, directly across from the Boot Hill Saloon. From the outside, the cemetery looks small, but it is actually quite large. It has two levels separated only by stone retaining walls. A beautiful coquina stone wall with decorative iron fences surrounds the cemetery.

I decided to call a neighbor of mine, Jim VanAlstine, a longtime resident and retired Daytona Beach city employee. I asked Jim if he knew anything about Pinewood Cemetery. He laughed a bit and began to tell me about a particular time when he and his crew were called upon to do a cleanup at Pinewood.

Some transients had broken into several of the crypts and set up housekeeping. The remains of the people buried in the crypts were tossed out like garbage. Makeshift ladders were used to gain entry to the bottom of the crypts. The vandals used blankets, candles and other items so they could *live* in the crypts.

When Jim and his crew arrived, they were shocked at the sight before them. Jim was unsure how to deal with the situation before him. He contacted the local authorities to see what should be done. The police arrived, and it was decided that Jim and his crew should not be the ones to correct the problem. City officials were notified, the crypts were cleaned up, the remains were placed back in their final resting places and the crypts were sealed shut. The cemetery would no longer have an easy way in at night.

Jim told me of many mornings when he was called out to the Pinewood area to wake some person or another from a night of partying. It seems even some of the locals enjoyed a night of rest in Pinewood. Some who

had too much to drink found comfy headstones to rest against and spent a night in the cemetery sleeping it off. I wasn't shocked to hear these stories. I've lived in this town a long time; nothing shocks or surprises me anymore. It does bother me, however, that the living have little respect for other living people and are even more disrespectful to the nonliving. After all, they can't argue or complain. Jim finally gave me a couple of leads on who to contact about further information on Pinewood Cemetery.

The following morning I began to make some phone calls. My first set of calls led me to the less-than-helpful staff of the local historical museum.

After many hours on the phone, I finally found the name and number of the caretaker of Pinewood Cemetery. I could feel my heart pounding as I listened to the phone ringing. An elderly woman answered and began to explain that her husband was the caretaker, but had recently become ill and was on a leave of absence. I felt like I had hit another brick wall as far as Pinewood was concerned. I could hear her rustling through some papers in the background as we spoke. Suddenly she began to recite a phone number! I jotted it down as quickly as I could. It was the number for Howard Wetherell. Howard Wetherell was now the fill-in caretaker at Pinewood Cemetery. He never saw his duties as chores or responsibilities. He was a kind and dedicated man whose devotion to caring for Pinewood Cemetery was his passion.

For many years, vandals took their toll on Pinewood. Graves were robbed. Mausoleums were broken into. Headstones were toppled over and broken, ornate brass gates and decorations were stolen and beautiful marble statues were destroyed.

Since I had lived in the area for quite some time, at this point, I knew the name Wetherell well. Howard Wetherell's cousin, T.K. Wetherell, was at one time the statehouse Speaker. I remembered this because I voted for him.

I thought for a moment before dialing the phone. I thought about how I would get this prominent member of the community to let me investigate paranormal activity in the cemetery he was in charge of caring for. I felt it best to be as honest as I could and make him understand that I was not going to disturb anything or anyone. The phone rang and a voice finally said, "Hello?" I asked for Howard Wetherell and explained how I had gotten his phone number. He laughed and asked, "How many hours do you need to do?" I couldn't imagine what he was talking about. Then it hit me—community service hours! I giggled and told him that I was not under any court order to perform community service hours, but if he needed some volunteers, I had a group that was anxious to get inside Pinewood Cemetery.

As we made our way along the path, shaded by old live oaks, we noticed how much damage had been done to this beautiful cemetery over the years. Not only had vandals taken their toll, but Mother Nature had been cruel, as well.

When the members of the Daytona Beach Paranormal Research Group, Inc. arrived at what appeared to be a utility shed, there were two men standing and talking to one another. We later found out that the younger man was a community service worker who was held in very high esteem by Mr. Wetherell. The other man was Mr. Wetherell, himself! We introduced ourselves, and I reminded him of our phone conversation. He was actually excited to see us. I was waiting for the right time to drop the bomb of our true intentions when he asked if we would like a tour.

We gladly accepted his gracious offer. This man had been working in the hot sun for most of the day, but he took time out—from a project that was obviously dear to him—in order to take a group of ghost hunters on a tour of his cemetery. At first I was a bit uncomfortable with a living person giving us a tour. We were pretty used to spirits showing us around. But as this kind man spoke, I was like a deer in headlights. The more stories he told, the more I wanted to hear.

The many biographies he relayed to me were so much more *human* than the ones I had read in books about local prominent people. Mr. Wetherell obviously had a passion for his work, and for Pinewood.

He spoke of the people at rest in his cemetery as if he knew each one of them personally. Maybe he did. He was not just spouting off facts about them, but had a true connection to them. I had never seen a cemetery curator or caretaker care so much about the lives of the once-living. Mr. Wetherell was a walking, talking testament to those who had passed on. The deceased lived through his kind and often humorous words and tales about them. What really struck me was that he didn't just tell us about the famous or prominent people; he told us about the far-from-famous ones as well. Even though some of these people had passed on long before Mr. Wetherell was born, he *knew* them!

Mr. Wetherell was the kind of man who became your friend after five minutes of conversation. Unfortunately, Mr. Wetherell's kind heart was his undoing. He befriended a young man who was serving community service hours at Pinewood. Mr. Wetherell believed in this young man—so much so that he fed, clothed and sheltered the young man. On July 3, 2001, Howard Wetherell's body was found lifeless on the floor of his condominium. He had been beaten to death. The young man was found a short time later in Virginia in possession of Mr. Wetherell's car.

Although the work restoring and caring for Pinewood Cemetery still goes on, Howard Wetherell is sorely missed.

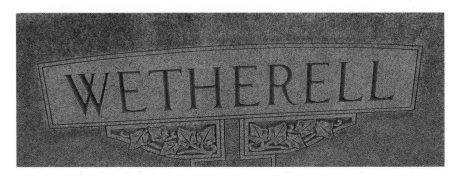

One of the Wetherell family headstones in Pinewood Cemetery. *Courtesy of Dusty Smith.*

After his death, a woman whom Mr. Wetherell had befriended went to pay her respects. She wasn't sure if he had been laid to rest in Pinewood or not. It didn't matter. She sat down under the canopy of an old oak tree where she and Mr. Wetherell had shared many conversations. She began to speak to him as if he were there. After several moments she began to weep; she missed her friend. She felt a hand gently touching her shoulder, but when she turned to see who was comforting her, she saw no one. She claims it was Mr. Wetherell trying to comfort her as he had done so many times before.

12

Spirits at Daytona's Field of Dreams

No good old American collection of haunting tales would be complete without a haunting associated with America's favorite game, baseball!

Jackie Robinson Stadium was constructed in Daytona Beach in 1930. The stadium still looks very much the same now as it did then, even down to the uncomfortable bleachers. Before I go into details about Daytona's own field of dreams, I need to tell you a bit about the man for whom the stadium was named.

Jackie Robinson, born Jack Roosevelt Robinson, in 1919, was the first player to break Major League Baseball's color barrier. Born in Cairo, Georgia, to a family of sharecroppers, he grew up in Pasadena, California. His mother, Mallie Robinson, single-handedly raised Jackie and her four other children. They were the only black family on their block, and the prejudice they encountered only strengthened their bonds to each other.

In 1945, there were few career opportunities open to black men, even those who had attended college. Jackie played one season in the Negro Baseball League, traveling all over the Midwest with the Kansas City Monarchs. In 1947, when Jackie Robinson first donned a Brooklyn Dodgers uniform, he pioneered the integration of professional athletics in America. By breaking the color barrier in baseball, the nation's favorite sport, he courageously led the way in overturning racial segregation.

In 1947, at the end of Robinson's rookie season with the Brooklyn Dodgers, he had become National League Rookie of the Year, with twelve homers, a league-leading twenty-nine steals, and a .297 average. In 1949, he was selected as the National League's Most Valuable Player of the Year and also won the batting title with a .342 average.

Jackie Robinson
Stadium in
Daytona Beach.
*Courtesy of Dusty
Smith.*

Banner of Jackie Robinson. *Courtesy of Dusty Smith.*

In 1997, the world celebrated the fiftieth anniversary of Jackie Robinson breaking Major League Baseball's color barrier. In doing so, we honored the man who stood defiantly against those who worked against racial equality, and we acknowledged the profound influence of one man's life on American culture.

There is a great deal of spirit activity associated with Daytona Beach's Jackie Robinson Stadium. Some people believe several of the fans still linger in the stands. It is even possible that some of the players of the past are still in the locker rooms or in the dugouts waiting their turns to smack homers out of the stadium.

The most active spirit in Jackie Robinson Stadium is said to be of one of the peanut vendors. While the man was standing near the top of the steps selling his peanuts to the crowd, he lost his footing. His body tumbled down the steps of the stadium. By the time he reached the bottom of the steps, he had broken his neck and died. Night security workers have reported seeing a man standing near the top of the stairs in the same location of the stadium where the vendor slipped. There have even been reports of a male voice calling out, "Peanuts. Get yer peanuts here."

13

The Lady on the Bridge

On the northeast side of the Memorial Bridge at Orange Avenue, at the bridge approach, there have been many reports of the spirit of a cloaked young woman with long, dark hair. No one is quite sure just who this young woman is, but her spirit is very active and sometimes violent. She has been spotted numerous times over the last few decades.

Some people think she may be the spirit of a young woman who fell off the old ferry once used to transport people across the river to the beach side before the bridge was built. When the ferry came to a stop, it bumped the dock hard. The young woman was sitting on the side rail, and as the ferry jolted, she fell into the river. Since she didn't know how to swim, she desperately tried to reach up to the ferry and pull herself onboard.

When she finally managed to grab hold of the ferry, she was in the worst location of all—the back end of the ferry, the part that had been continually bumping into the dock. As she held on for dear life, the ferry again slammed into the dock, crushing her between the ferry and the pilings. The ferry hands finally rescued her from the waters, but it was too late. The internal injuries she sustained were beyond the medical technology of the day. They laid her out on the bank of the Halifax River and tried their best to comfort her as she breathed her last breaths.

Others believe she may be the spirit of a runaway teen who made her way to Daytona Beach from parts unknown. Apparently this young girl had hitchhiked to the area, as many do. When she realized that living on the streets of Daytona was not much better than the life she had escaped, she started panhandling in the Beach Street area to try to get enough funds to get back home.

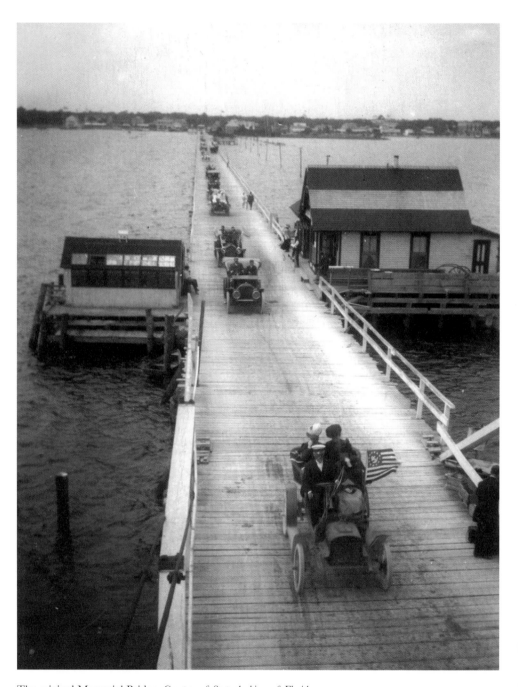

The original Memorial Bridge. *Courtesy of State Archives of Florida.*

During this time, she actually slept under the bridge. One night, after bedding down, she was approached by a man. She resisted to the best of her ability, but a local fisherman found her lifeless body early the next morning.

The autopsy showed that the girl had been raped. Reports, including an artist's sketch, went out in an attempt to notify the young girl's family. There were no responses. She was finally laid to rest in a Jane Doe grave in one of the pauper cemeteries. The man who so senselessly ended her life was never apprehended.

Could it be her spirit that still haunts the bridge? Since the spirit of the Memorial Bridge is sometimes violent, it very well may be the spirit of either of these young girls, still trying to fight for life.

Another possibility is that it may be the spirit of a young girl who was killed in a hit-and-run drunk-driving accident.

Her name was Rose and she lived with her aging grandmother in the downtown area. Rose's mother died during childbirth, and her grandmother gladly took on the responsibility of raising Rose. Since they were of meager means, Rose's grandmother often made their clothing. Rose's favorite article of clothing was a cloak her grandmother had made for her one fall when she was only twelve years old. She looked forward to the cooler weather so she could wear the beautiful but heavy cloak.

When Rose was in her final year of high school, she decided to attend the school's homecoming dance. The dance was being held in the ballroom of one of the hotels just across the bridge, and Rose decided that the walk would be nice. She put on her best party dress, a bit of makeup and the beautiful cloak her grandmother had made for her and headed out into the night.

As she started up the approach to the bridge, she watched the lights from the opposite side of the river dance across the water. She noticed headlights coming over the bridge, but didn't think much of it; after all, she was walking safely on the sidewalk.

As the car got closer, she noticed the vehicle was weaving a bit. She still didn't concern herself with the matter; she had thoughts of the dance running through her head. Suddenly the car swerved, jumped the curb and hit poor Rose, killing her on impact. Her lifeless body was thrown several yards from the impact site. Her shoes wound up under the bridge, her cloak resting on the safety rail of the bridge. The bridge tender at that time recalled that the cloak looked as if she had gently placed it there.

All reports—and there have been hundreds over the years—of this young woman state that she has long dark hair and wears a cloak. The documented violent activity associated with her includes chairs being

thrown onto the approach of the bridge even when there is no wind, shoes being thrown at cars passing by and one report of a lone young woman accepting a ride across the bridge. She got into the car wearing a cloak. She did not speak, but only pointed across the bridge. When the person who offered the young girl the ride got across the bridge, the young woman was no longer in the vehicle. Could this be the spirit of Rose, still attempting to get to the homecoming dance?

14

The Spirit of Lucille

Just across the Halifax River, on Silver Beach Avenue, is a beautiful Victorian house next to the foot of the Memorial Bridge. This was the first home ever built on the Daytona Beach peninsula, and it has come to be called Lilian Place. Alice Dalton named the house in Lilian Thompson's honor because she was the original family member who lived there the longest. When it was built, there were no bridges to the mainland. In order to cross the Halifax River, residents and visitors to the home had to row, sail or take the ferry.

Built in 1884 by the Thompson family, Lilian Place is the most documented haunted home in the Daytona Beach area. Before I get to the ghost, I must first tell you of how Lilian Place came to be.

The Thompson family moved to the Daytona Beach area with a man named Mathias Day, the man Daytona Beach was named after. In 1875, Day and the Thompsons, along with a few other families, moved from Cincinnati, Ohio, to Daytona Beach.

Laurence and Mary Eliza Thompson, along with their children, decided to settle in the area during the Florida land boom. At that time, there were no bridges from the mainland to the beach side.

When the Thompson family decided to build their new home, they chose a location that is now 111 Silver Beach Avenue. The main portion of the house had three stories, a full ground-level basement, an observation tower and plenty of Victorian gingerbread carvings. The home was so large and isolated that it was the envy of many of the mainland residents. The few Native Americans still venturing into the area were not impressed. It seems that the Thompson family had chosen to build their new mansion over the top of a Native American shell mound. Some say the family was cursed for doing so.

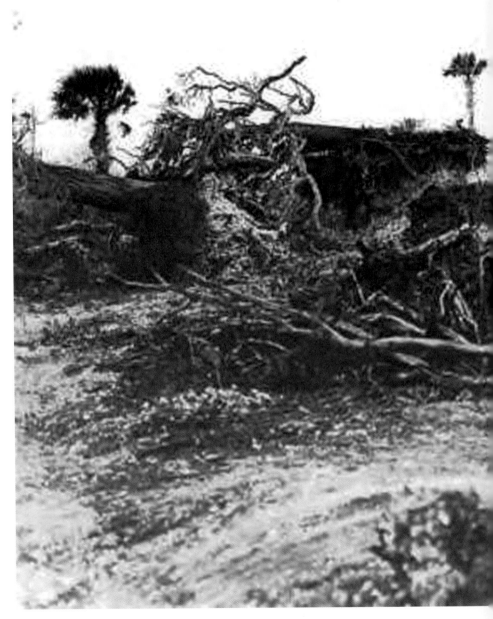

Native American burial mound destroyed during building. *Courtesy of State Archives of Florida.*

Congregational Church attended by the Laurence Thompson family. *Courtesy of State Archives of Florida.*

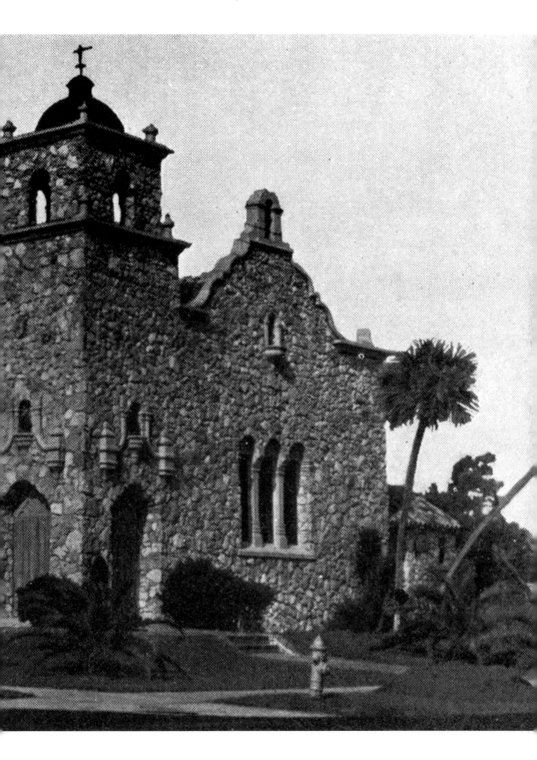

Laurence and Mary Eliza had two sons, Laurence Jr. and Harrison, better known as Harry, who was the first Thompson born in Daytona Beach. They also had a daughter named Lilian. Laurence Jr. became a prosperous businessman; Lilian took up her days playing piano and reading; and Harry was more of a playboy who marred the family's good name on more than one occasion.

Even though the purchase of alcoholic beverages was illegal at the time, Harry managed to find an ample supply. He smoked, liked racing cars and boats and enjoyed the company of, shall I say, "loose" women.

When Harry was in his mid-twenties, he met and married a divorcée who was visiting the area from France. Divorce was not seen as an option in those days, so Harry's new wife, Lucille, was seen as a gold digger and the whole affair was quite scandalous. Possibly as a way to save face in the community, the Thompson family became very active members of the Congregational Church.

Before Harry and Lucille's marriage, it was said that Harry was already engaged to another young woman who was living in the upstairs room of Lilian Place. This young woman was also named Lucille. She had agreed to marry Harry and had moved into the Thompson home as the couple planned their wedding. Her dream soon became a nightmare. When she was told the news of Harry's new betrothal, she fell into a deep state of depression. With no family, no job and nowhere to live—except for Lilian Place, the home she was supposed to share with Harry—Lucille was not long for this world. It is said that the jilted fiancée took her own life by climbing the stairs to the observation tower, better known as a widow's walk, where her morose state led her to jump to her death into the bed of lilies below.

When the *Commodore* sank offshore of Daytona Beach, the Thompson family's name was drawn at their church to house one of the survivors, a man by the name of Stephen Crane. Stephen Crane had already authored a book, *The Red Badge of Courage*, and would soon pen a short story called "The Open Boat," about his shipwreck experience in Daytona Beach. Before he left the Thompson home, Stephen Crane inscribed a copy of his book. The inscription read, "To the Laurence Thompsons, in gratitude for taking in a shipwreck survivor."

The house was passed down through the Thompson family for four generations. When Memorial Bridge was finally built, connecting the beach side and mainland, many wild and domestic animals were killed by road traffic. Many of these lost little lives were laid to rest by Lilian on the property of Lilian Place in a small pet cemetery.

Some of the descendants of Laurence and Eliza still live in the Daytona Beach area, but when the large old home became too much to keep up

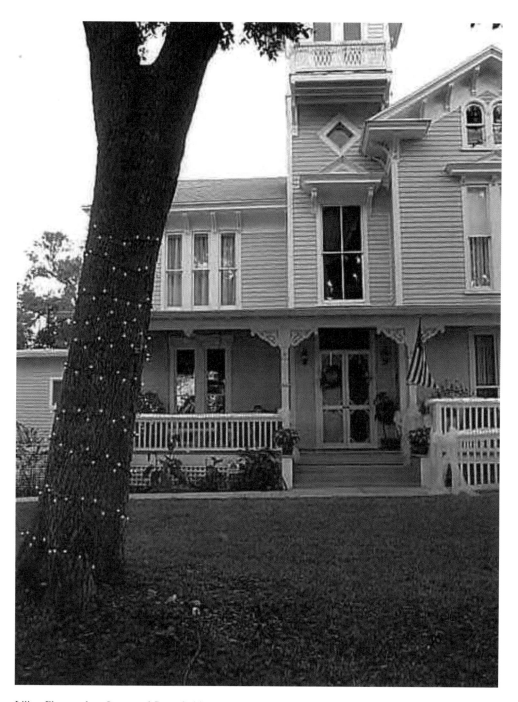

Lilian Place today. *Courtesy of Dusty Smith.*

with for the owners, they began to rent out rooms within the home. Since there are so many large rooms in Lilian Place, it was easy to convert them into small apartments. Many people of all walks of life have rented rooms at one time or another in the once-grand mansion. Renters have included alcoholics, transvestites, trigger-happy hippies and even small hardworking families.

When the house finally fell into disrepair, it was sold to the McDoles by the last Thompson family member to reside at Lilian Place. Mr. McDole was a young city attorney with a family and was very exited about restoring Lilian Place to its once-grand status.

From early on, there have been reports of spirit activity within the walls of Lilian Place. Could Lilian's spirit still reside within the home? It is said that the female spirit is kind. The spirit is also motherly. Lilian Thompson never experienced children; she died a spinster.

We may never know if it is Lilian Thompson, Lucille, the jilted lover or another woman, but whomever it is, she is very interactive with the still-living housemates.

Faucets throughout the house turn on and off by themselves. Vacuum cleaners have turned on and begun to run across carpets by themselves. Lights turn on in the middle of the night, seemingly turned on by unseen hands. Door latches are hooked from the outside. Many reports of a woman dressed in clothing from the 1920s have been recorded. A few residents of the house have also held conversations with the female spirit.

The strangest report of this female spirit interacting with living residents involved the Bennett family and their infant daughter, Vicky. The Bennetts were throwing a small dinner party, and Mrs. Bennett had put her daughter, Vicky, down in her crib to sleep. Vicky was four months old at that time. When Mrs. Bennett climbed back up the stairs to check on her daughter, she was no longer in her crib. She was lying sound asleep on a blanket in the middle of the nursery-room floor. Her blanket had been placed lovingly and carefully around her, and no one had been up the stairs.

Mrs. Bennett had become used to the interaction by this time and saw the event as nothing more than the spirit of the woman who had become known as Lucille. Lucille seemed to enjoy interacting in a most loving and protective way when children lived within the walls of Lilian Place.

15

Ghosts Search for Love, Too

Maggie once lived in a small bungalow on Auditorium Boulevard, in Daytona Beach. During Prohibition, Maggie met and fell deeply in love with a rumrunner named Harvey. Maggie is in the history books of Daytona Beach as being our very first "working girl." Even though she was a lady of the evening, Harvey didn't care; he loved Maggie.

Whenever Harvey sailed into port, he stayed with his beloved Maggie. His visits usually lasted between two and six weeks before he took off to brave the sometimes-stormy Atlantic Ocean once again. Maggie had a morning ritual. She made a habit of putting on her finest dress and all of her makeup and walking down to the beach just after sunrise to wave at Harvey's ship as it passed by in the sunlight.

While Harvey was away, Maggie walked from the bungalow they shared to the shore to watch the ships sail by. Maggie's path to the beach remained as steadfast as her love for Harvey. She exited the bungalow, walked down Auditorium to Oleander to Harvey Avenue and then straight down to the shore. Her heart ached, and she longed for the man she so deeply loved. She could almost hear his voice in the mournful cries of the seagulls.

On one of Harvey's trips out of town, a severe storm blew up the East Coast. It cut a path that took several lives and destroyed not only the shoreline and hotels, but also Harvey and Maggie's happiness. Harvey's ship was lost at sea; there were no survivors.

When they came to tell Maggie that Harvey was gone, she refused to believe them because they never presented her with his body. Maggie fell into a deep depression. She saw no visitors. She barely ate and rarely slept. She continued her routine of getting up before sunrise, putting on her finest dress and all of her makeup and following her route to the seashore.

The storm that caused Harvey's death. *Courtesy of State Archives of Florida.*

Maggie and Harvey. *Courtesy of State Archives of Florida.*

Maggie's path to the beach soon became famous. Any of the locals who happened to be awake at that hour watched her sadly float along her route.

It took Maggie only a few short weeks of suffering before she finally starved herself to death. When they discovered her body, she was lying in the bed of the bungalow wearing her finest dress and all of her makeup, with the only known photograph of herself with Harvey tucked lovingly against her chest.

If you pick up Maggie's route on the corner of North Hollywood Street and Auditorium Boulevard just after sunrise, you will be joined by an eerie wind all the way to the shore. It is widely believed that this is the spirit of Maggie, still going to wave at the ships as they pass by.

16
Man's Best Friend, Even in the Afterlife

At one time, the most popular resident of the Daytona Beach downtown business area was not a human being. I will now tell you about the most popular goodwill ambassador Daytona Beach has ever had. I am speaking of a dog that came to be called Brownie.

This wise traveler somehow made his way to Daytona Beach. Like many before him and many more after him, Brownie explored the sidewalks and storefronts of Beach Street for several days before staking a claim.

Brownie's first, and soon to become best, friend was Ed Budgen Sr. Ed was the owner of the Daytona Cab Company, located on the corner of Orange Avenue and Beach Street. When Brownie met Ed, Ed offered Brownie part of his lunch. Now, as a smart and resourceful dog, Brownie gladly accepted the free meal.

Brownie quickly learned how to capitalize on this gracious human inclination. Many of the downtown workers and restaurant owners fed Brownie scraps on a regular basis. Brownie took up residency at the Daytona Cab Company. Brownie's new friend, Ed, even made him a doghouse from a cardboard box. Eventually, Brownie's home became a bit more upscale and was made of plywood. It was quite an elaborate home, complete with Brownie's name on it, and a collection box was added. Many people donated to the Brownie Care Fund. This fund provided food, veterinary care and money for Brownie's annual license. C.P. Miller made sure that every year Brownie got tag #1, since Brownie was the goodwill ambassador for Daytona Beach.

One local resident remembers that Brownie took up residence in 1940. At this time, downtown shopping was popular. Brownie quickly became known as the town dog. It was customary to see and greet Brownie while

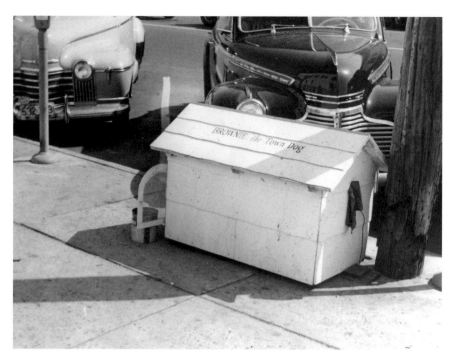

Brownie's doghouse outside the Daytona Cab Company. *Courtesy of State Archives of Florida.*

on your shopping spree. His reply was always a wag of his tail. One of the benefits of being the town dog was an occasional free pint of ice cream, which Brownie loved.

Brownie became a trusted companion to many of the local cab drivers. He took it upon himself to accompany the police patrolmen on their nightly rounds. Brownie assisted the officers by sniffing at shadows in dark alleys and standing at the sides of officers while doors of the local businesses were checked.

Brownie's fame grew, but his ego didn't, even after he was written up in national magazines and newspapers as "Daytona Beach's Dog." Many visiting tourists sought out Brownie as they walked and shopped along Beach Street. They wanted to have their pictures taken with the country's most popular dog. Ed's wife, Doris, remembers Brownie getting Christmas cards and presents from all over the country. Doris responded on Brownie's behalf, and she always included a photo of the famous dog.

Brownie passed of old age in October of 1954. Many of the fine folks from across the country felt the loss and sent letters and cards of condolence. Brownie's bank account had enough money in it to purchase a headstone and construct a plywood casket. City officials provided a resting

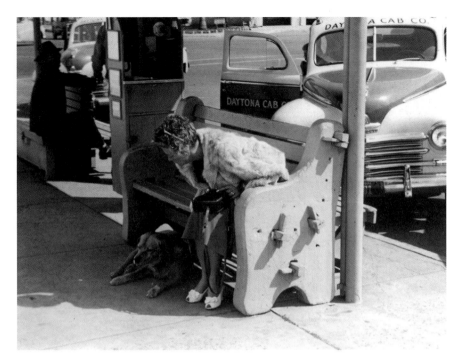

Brownie visiting with a tourist on Beach Street. *Courtesy of State Archives of Florida.*

place in Riverfront Park, directly across from the place that Brownie had spent the best years of his life.

At Brownie's funeral, there were four pallbearers and seventy-five people in attendance. Mayor Jack Tamm stated in Brownie's eulogy, "Brownie was indeed a good dog," as many shed tears.

As I stood there thinking about this goodwill ambassador and what a wonderful impact he had on this town and the folks who were lucky enough to encounter him, I suddenly felt sad. I wondered how many people still remembered this fine animal. At that moment I decided to take Brownie on as my very own spirit pet. I visit him as often as I can. I talk to him and offer him biscuits.

I noticed a park bench near Brownie's place of rest. It seemed so inviting. The soothing thought of sitting on a park bench—dog at your side, listening to the wind and watching the traffic go by—made me hope that if Brownie's spirit was in the area, he would join me. I told Brownie that if he cared to join me, I would be more than happy to sit with him. After several minutes, I felt warmth at my left leg. At first this bothered me a bit. After all, Brownie was a male dog!

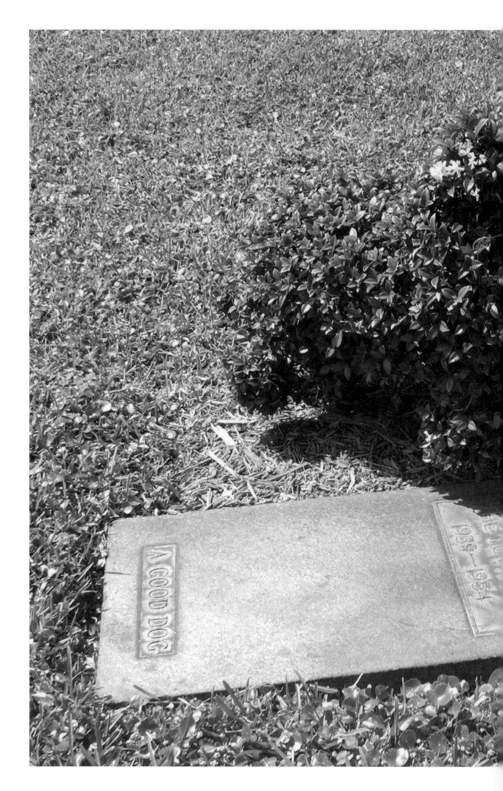

Brownie's gravesite in Riverfront Park. *Courtesy of Dusty Smith.*

It seems to me that this famous goodwill ambassador is still doing his job of sitting next to visitors or weary travelers in a cool shady corner of the park, keeping an eye on the passing traffic, walking alongside pets that still reside in this world and maybe even romping through the park to visit with otherworldly residents of the park. Whatever the case, Brownie is still doing his job, and he will always be "a good dog."

17

Possessed Artifacts in the Merchants Bank Building

The Merchants Bank building was commissioned in 1910 by Charles Burgoyne and was operated as a financial institution until the Great Depression. It became the Florida Bank & Trust from 1936 until the 1960s.

On the inside north wall, a local artist, Don Emery, and his son painted five huge murals depicting scenes of the local area in 1951.

When the last bank left the building for a larger facility, the building was deserted. With a few attempts at small businesses, such as a gift shop and even an upscale restaurant, the building remained vacant for the most part, until 1984, when it was purchased by the Halifax Historical Society.

In 1986, the Halifax Historical Society opened its historical museum in the building originally designed by the architectural firm of W.B. Talley, Hall & Bond. The building remains in its care to this day and is listed with the National Register of Historic Places. It still boasts original architecture, including stained-glass windows, skylights, decorative carved plaster, beautiful mahogany and brass lighting.

Although the building remains the same, the exhibits within the museum change. The energy attached to some of these displayed items may explain the activity that occurs within the walls of the museum.

At one time, a Native American canoe was on display in the museum. The canoe was originally found near a known ancient Native American settlement in Volusia County. The canoe was found to be about 5,400 years old, and it is said to have been carved out of a palm tree by the Native American Seminole tribe.

After the canoe was found, it made its rounds throughout the state to various museums. After resting for awhile at the Halifax Historical

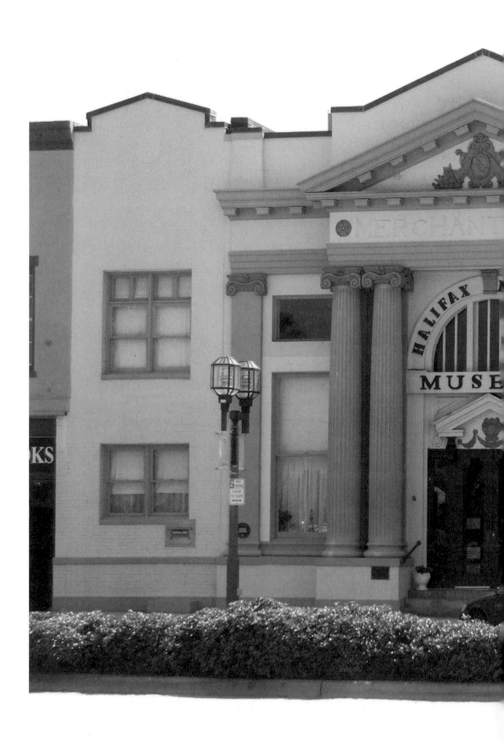

Merchants Bank Building today. *Courtesy of Dusty Smith.*

Society's museum in Daytona Beach, the canoe was ready to make its journey to Tallahassee.

The now-petrified wood was heavy, but not astoundingly so. When the two workmen came to move the canoe, they soon discovered that they couldn't lift it. They called for a third worker to help, then a fourth and a fifth. After finally adding the tenth man to help lift the canoe, and asking permission of whomever or whatever was holding the canoe in place, the canoe lifted with ease, and several of the workers didn't even break a sweat in assisting. These workers claim that a Native American spirit was preventing the canoe's transport until the proper respect was paid.

Another interesting spirit-related activity that occurred within the museum involved many of the small figurines in one of the displays. It seems that someone not of this world didn't like the way the figurines were displayed in this particular exhibit. For a very long time, when the workers arrived in the morning to open the museum for the day, many of the small figurines from the display that showed the boardwalk area of Daytona Beach had been rearranged, or even knocked over, during the night.

These small, hand-painted pewter figures of people are randomly placed in the display to show how active and popular the boardwalk area was in its heyday. This incident happened so frequently that workers finally decided to use superglue to keep the figurines in place. Maybe the art-critic spirit that rearranged the figurines didn't think they should be where the staff who designed the display had placed them. Maybe the spirit was just mischievous and enjoyed annoying the museum staff. Or maybe the spirit was once a resident of the area and knew that the way the display was set up was inaccurate. We may never know the answer; the superglue seems to have put an end to that particular form of spirit activity.

The most active spirit that haunts the old Merchants Bank building was a longtime resident and quite a fashionable socialite. She is known in the museum as Marian, and at one time she was the wife of a prominent citizen.

Marian married her affluent husband in June, like any socially aware woman did. The gown she wore was the most beautiful anyone in the area had ever seen. It had a fitted bodice of white satin, a high, ruffled neck and long, full sleeves, and was graciously detailed with tiny, white seed pearls. The skirt was bustled and floor-length and flowed down to a long train in the back. Her veil was adorned with satin flowers and pearls on the crown and was nearly as long as the dress's train. To complete this bridal ensemble, she had a matching camisole and petticoat, white silk stockings with feathered garters, white satin shoes and an ivory and silk hand fan.

Marian became the woman to look to for the latest fashions in town. She attended many balls, teas and other functions of the social elite and was sure to be wearing the latest and most desired fashions. She became a bit consumed with her fashions and quite attached to her clothing and other unique and expensive personal items.

After her death in 1979, her children donated her beautiful wedding ensemble, along with other personal items, to the museum. Marian was very attached to these articles when she lived, and this attachment is said to be what still holds her spirit close to them inside the museum. In the paranormal field, this phenomenon is known as "possessed possessions."

Many reports of seeing, or even feeling, her presence have been reported by staff and visitors alike. These reports include such paranormal activity as objects being moved around, lights turning on and off by themselves, cold spots and even footsteps. Most of the staff just giggle and say, "It was just Marian."

In the eighties, when local police still walked a beat along Beach Street, they reported seeing a woman floating along inside the building in a long white dress. Could this have been Marian donning her beloved wedding dress once more?

The most famous Marian sighting occurred in 2001. She appeared as a foggy white light that seemed to be a reflection. Upon further inspection, it was realized that there was no possible natural explanation for the light to be reflected from anywhere in the building into the back of the old bank vault were Marian's wedding dress is displayed. The eyewitness also reported a bone-chilling cold breeze within the vault as he began to exit the location.

That very same night, there were several unexplained occurrences within the museum. The most notable event was when the glass candle globes used to illuminate the building suddenly tumbled over and fell to the floor. That night, there were several visitors in the museum attending a special fundraising event. None of the guests were anywhere near the globes at the time. The ghostly event had several witnesses, some of whom were frightened to the point of leaving the museum, never to return.

It is thought that Marian's spirit may be afraid of fire, which is why she interacted with the globes that covered the gas lamps that night. She was known in her life to have an irrational fear of fire and many times commented to close friends that she feared losing her life to a fire.

She may also still like to admire herself in her precious wedding gown. At another function in the museum, a woman entered into the ladies' restroom. As the woman passed the mirrored wall above the sink area, she noticed a tall woman with dark hair and a long white dress standing there.

The visitor realized that the woman in the mirror had a strange look to her, and when she turned to acknowledge her presence, the young woman was not there.

When the guest turned back to the mirror, the reflection of the young woman was gone. She froze for a moment and questioned her sanity while exiting the restroom. As the door was about to close behind her, she decided to give one more look around. There was no one besides herself in the restroom. She had plainly seen the young woman in the long white dress. She was certain of it.

If you visit the museum, be aware of strange sights and sounds, but don't be afraid. It's just Marian's spirit still being social and fashionable in the place where her precious wedding gown resides.

18

Alcohol or Spirits?

Several years ago I heard a quote. I believe it was originally said by Albert Einstein, and it is, "one of the definitions of insanity is repeating the same steps over and over and expecting a different outcome."

It was Halloween. My friend Rosalind and I sat in my front yard passing out candy to the trick-or-treaters and deciding what we would do when the candy was gone. We decided to head over to my friend George's pub. I had my camera out that night, as any good ghost hunter should. After all, the day of the dead is the best for taking ghost pictures. I took some shots in my front yard. These shots had excellent results—results that made me not want to venture into my front yard at night alone for a while.

After passing out the candy and taking several photos, Ros and I decided to go see my old friend George at Panheads Pub. There weren't too many people in the pub that night, but we managed to have a good time. When I saw that everyone was in a happy mood, I broke out the camera. From the first shot, I was amazed! I got home and saw the photos and I decided I needed to spend more time at Panheads Pub.

I began cautiously speaking to the employees and a few precisely chosen patrons, hoping that no one would get too suspicious of what I was doing. No such luck, though. Within three weeks, every time I walked through the door someone yelled out, "The ghost lady is here!" So much for trying to keep a low profile! I began to openly discuss my research and ask around about the activity in the pub.

George told me of several incidents when he heard noises when the pub was empty. He never felt alone in the pub; he felt like someone was watching him, but not in an uncomfortable way. Another employee told me how the previous proprietors had been killed in a car accident a few years ago.

The happily married couple was on the way home from a party when the limousine they were in struck a tree. They both died from their injuries.

I began to research the couple. Sure enough, the story was true. The same man has owned the property since 1953, but he leases it out to anyone with the rent money. When Ronnie and Suzie Johnson leased the property, they opened a bar. When the limousine hit the tree that fateful night in December 1994, my guess is that neither of them was ready to move on to the next plane. It is quite possible that their spirits remain at the bar they once operated. There is still a marker near the tree, just past Tomoka State Park, near Highbridge Road in Ormond Beach, that is a reminder of the passing of this happy, industrious couple.

There have been many patrons of this building over the years. When I first moved to the area, in 1979, it was a bar named Chuck's Tavern, and it was a very popular meeting place for many locals. Then it was Cousin J's, Pasta Pete's, Armadillos and finally, Panheads Pub.

With the thousands of people who enjoyed gathering in this place, it's no wonder it has some interesting spirit activity. Also, the building is located on a main intersection in town. The spirits here may be past customers, past proprietors or unfortunate souls struck down while crossing the busy intersection or involved in a vehicular accident just outside the door. As I read through thousands of old obituaries, I noticed that there was mention of several people who had died over the years in this location.

My theory on the spirits of Panheads Pub is that there have been so many folks over the years that have enjoyed throwing darts, shooting pool, watching Sunday football or baseball games or just enjoying the other friendly patrons of the pub that they choose to stay and have a good time here.

If you're ever in the Daytona area, stop in 1130 Ridgewood Avenue in Holly Hill. See if you can get the spirits to toast along with you at Panheads Pub.

19

Pushin' up Pink Phlox Flowers

One of the most colorful characters of local Daytona Beach lore became know as "the Pink Lady." She picked up her nickname because everything she wore was pink. Her hats, blouses, skirts, shoes, shirts—and, so we're told, even her undergarments—were always pink.

Her real name was Katherine, and she was married to a very jealous man by the name of Jonathan. She was a sweet, good-natured woman who enjoyed gardening. The two loves in her life were her husband and her gardening. Jonathan had one love in his life, and that was Jonathan!

As she aged, she found she had trouble keeping up with her gardening chores. A severe form of arthritis had set into her hands, hips and knees. She asked her husband if it would be all right if she hired a local man to assist her with her gardening chores. Being the jealous sort, Jonathan resisted this idea at first. The thought of another man close to his wife drove him insane. But, when Jonathan finally realized that if he didn't allow Katherine to hire someone to help with her gardening chores, he would have to do them, he agreed.

Katherine interviewed several young men, and she finally decided on the young man that had the right experience to do the jobs that Katherine knew she would need to have done. Jonathan noticed the young man's good looks and his jealousy began to consume him.

Katherine and the young man had a deep love and enjoyment for gardening. They talked for hours on end about different flowers and shrubs and ways to keep them healthy. At first, Jonathan didn't mind the young man helping his wife in the garden. However, his jealousy eventually got the best of him, and he began assuming that there was more than just gardening taking place.

Jonathan began to closely watch the way his wife looked at the young man. He noticed the way their hands touched when she passed him a flower to be planted. He saw passion in their eyes as they glanced at one another over the pile of cow manure. All of this was, of course, in his mind. Katherine and her helper shared only the love of gardening and each other's good company, nothing more. Jonathan eventually became so consumed with his jealous thoughts that he decided to confront the two, but separately.

While his wife sat watching the sunset, the gardener was leaving for the day. Jonathan jumped off the porch and asked the gardener if he had made advances to his wife. Shocked, the gardener replied, "No!" Jonathan did not believe him and fired him on the spot.

Next, Jonathan would confront Katherine. After dinner, he became enraged with his thoughts. He realized that he couldn't just accuse his wife of adultery, so he eased his way into a conversation about her garden. When Katherine realized the direction that the conversation was headed, it quickly heated into an argument. During the argument, Jonathan accused his wife of having an affair with her hired help. Without thinking first, Katherine retaliated by telling her husband, "No, not yet, but his time will come!"

Upon hearing those words, Jonathan reached across the kitchen table and strangled Katherine to death. He dragged her body outside to the yard and he planted her in her precious flower garden. Realizing that someone might notice this human-shaped mound of dirt in the yard, Jonathan knew he needed to cover his tracks. He looked around the backyard and found several trays of pink phlox flowers. How fitting for the pink lady! He planted the pink phlox flowers atop the spot where he had buried her body.

The following morning, Jonathan packed up their home and left the Daytona Beach area. He stayed away for approximately seven years. He kept an ear out for any news of his wife's death, but never heard a thing about it. He finally decided it was safe to return to the house and check on his wife and her makeshift grave.

He waited and watched as the family that now resided in the home left for the day. He made his way back to Katherine's garden and began poking around for his wife's remains. To his surprise, she was no longer there! He began to panic. Jonathan's next logical thought was that the family that now lived in the home may have discovered Katherine's remains and assumed it was a family burial. They more than likely wouldn't want the responsibility and upkeep of someone else's loved one, so they may have had her remains exhumed and moved to the cemetery.

Jonathan calmed himself the best he could, took a deep breath and headed for Pinewood Cemetery. As he walked along the dirt driveway, he read the names on the headstones. When he finally came to a bend in the driveway, he discovered the grave with Katherine's name on it. Again he was surprised. The entire grave was covered in pink phlox flowers! He immediately suffered a massive heart attack and died, his lifeless body falling across her grave.

If you visit Pinewood Cemetery in the early spring when the pink phlox flowers are in full bloom, you can still see the imprint of Jonathan's body in the pink phlox flowers on Katherine's grave.

20

Ghosts Still Take Center Stage at the Seaside Music Theater

The Seaside Music Theater, in Daytona Beach, was part of the original Beach Street business district. The building that now houses the Seaside Music Theater is now also the home of several spirits.

When extensive remodeling was taking place inside the theater, one of the contractors noticed a well-dressed man standing off to the stage-left area. The contractor became confused over some design conflicts and decided to ask the man, whom he believed to be at least somewhat in charge.

As the contractor discussed the design conflict with the well-dressed man, he got no response. The man just stared at the contractor. The contractor later reported that all this man did was stand there, glaring at him with a very stern look on his face, while he puffed on a big cigar. After realizing that he wasn't getting anywhere with this person, the frustrated contractor went to the front office to seek other assistance.

In the office he told the secretary about the incident with the man he had assumed to be the manager, and how displeased he was with him. The secretary looked a bit confused and finally told the contractor that the only people in the building were the two of them. None of the other staff, including the manager, would be in until later that day. The two assumed that someone else, someone who should not be in the building, might have entered without their knowledge. When they went to the stage area, there was no one there. All of the doors were locked securely, but the smell of cigar smoke was still very heavy in the air.

The local police were called, just in case the man the contractor saw might still be lurking somewhere else in the building. They did a thorough search and found nothing—nothing but the still-strong smell of cigar smoke.

When the manager arrived for work that evening, the secretary told him what happened that day. He started to chuckle and told her about the spirit of a past stage manager who makes his presence known in the theater whenever major changes are being made. He also told her that he seems to always have a stern look about him, and when he isn't actually visible, there is always the scent of cigar smoke in the air.

Another spirit, strong in her desire to remain at the Seaside Music Theater, is thought to be the spirit of a young woman who was once an understudy to a long-running show. Though she never was recognized for an onstage performance, her talents were recognized by the manager of the theater. It seems that while the two were having a secret love affair, the manager's jealous wife discovered just how talented the young actress was.

While paying an unannounced visit to the theater one night, the manager's wife opened the office door to find the two lovers together. The young actress raced through the theater to her dressing room, half-clothed and screaming in an eerie cackle. The manager tried to explain his actions to his jealous and now-raving wife. She smacked his face and slammed the office door behind her as she left. He didn't realize what his wife was about to do. He assumed that his wife had left the building. In fact, she made her way to the back of the theater and confronted the young harlot who had led her husband astray.

The argument between the two reached a fevered pitch, and with no forethought, the wife bludgeoned the young actress to death with a handy stage prop.

It is said that if any jealous woman or any unfaithful man enters into the Seaside Music Theater with less-than-honorable thoughts in mind, the spirit of the young actress will begin to cackle in an eerie tone that can be heard going from the front office to the backstage area.

The saddest—but most mischievous—spirit that dwells within the walls of the Seaside Music Theater has to be that of a young boy. His first—and, as you'll soon learn, only—experience with the theater was not a pleasant one.

The boy was the son of an affluent couple who lived in Daytona Beach. The couple requested that the nanny accompany their young son to the theater one afternoon so he could be exposed to it in a proper manner.

This young lad was escorted to a matinee show on a Saturday afternoon. He was so excited while watching the show that he kept getting out of his balcony seat to get a closer look.

Being quite young, he had not yet been schooled in proper theater-going etiquette. The woman who had charge of the young boy on this day

The Seaside Music Theater building today. *Courtesy of Dusty Smith.*

politely kept reminding him that young gentlemen do not act this way in a proper theater.

With each reminder, the young boy once again took his seat. Near the end of the third act, and several reminders later, the young lad decided that he was going to take a stand and be as close as he wanted to be to the stage. He stood with his back to the balcony railing and defiantly challenged his adult caretaker. When she reached out to assist the boy back into his seat, he leaned away from her and fell to his death over the railing.

Ever since the young boy's death, there have been numerous reports of hair pulling, childish laughter, small personal items being moved about and the strange, shadowy figure of a small boy running around, sometimes hiding in the balcony of the Seaside Music Theater.

21

Love Never Dies

At one time, the Brass Rail Tavern was the most popular tavern in town. In the early 1900s, the Brass Rail was conveniently located on the corners of North Coates and Main Streets in Daytona Beach.

In its heyday, the Brass Rail Tavern was the place to be for the working class. Many of the locals stopped in on a daily basis after a hard day's work to relax, unwind and visit with other patrons of the tavern.

In the days just after the repeal of Prohibition, a woman everyone called "Miss Bonnie" worked as a tavern maid in the Brass Rail Tavern. Bonnie was a short, stout woman who stood only three feet, eight inches tall but weighed about 230 pounds! Despite her short stature, she was hardworking and popular.

When she began working at the Brass Rail Tavern, her boss made her a short barstool to assist her with getting liquor from the top shelf. Since Miss Bonnie was so short, she often asked another worker to aid her in getting the bottles from their lofty resting places. Her boss saw this as paying two employees to do the job of one, so he made her the barstool.

Miss Bonnie became known locally for carrying her barstool around town with her. She took it to the feed store, the pharmacy and the general store. Now she didn't need to ask for assistance with items she needed from higher shelves.

Slim worked at the local livery stable on North Halifax Avenue. He lived in the feed and tack room. He was provided with transportation as a part of his salary. This transportation was no thoroughbred; she was an old swayback mare. Slim was a very tall man. They say he stood seven feet, six inches tall. He was so tall, and the horse was so swaybacked, that his boots dragged along the streets when he rode his horse down Main Street on his daily ride to the Brass Rail Tavern.

Slim and Bonnie were in love. They had established a nightly ritual that locals liked to see. Since Bonnie was so short compared to Slim, she slid her barstool up next to him so she could reach his cheek to give him a kiss goodnight. This ritual continued for some time. Finally, one evening Slim decided to take the next step in his relationship with Bonnie; he offered to escort her home. She happily accepted and grabbed her stool on the way out the door.

Bonnie climbed up onto Slim's horse with him and Slim reached down and picked up her stool. When the rather odd-looking couple arrived at Bonnie's home, Slim set her stool down and helped her climb down off the horse. Bonnie turned back toward him to give him his kiss goodnight.

This became a pattern, until one night when the odd couple arrived at Miss Bonnie's home and she climbed up on her stool to give Slim his kiss goodnight. Slim dropped to one knee and popped the question! Bonnie gladly accepted and she gave Slim his goodnight kiss on the cheek. Slim waited for Miss Bonnie to get inside her home, climbed up on his old mare and headed back for the livery stable.

It was cold and foggy that night, and Slim's head was foggy with beer and thoughts of his feelings for Bonnie. As he rode through the foggy streets, he didn't see a low-hanging tree branch. The branch hit Slim and toppled him off his horse, landing him in the street with a broken neck.

Slim's horse paid little attention to the fact that her passenger was no longer astride her. She lazily meandered back to the livery stable. The horse didn't realize there was a tragedy awaiting her in the dark, dense fog as well.

Someone had closed the stable gate. Slim's horse walked smack into the gate and broke her neck, too. Both Slim and the horse died of their injuries. When Bonnie was informed of the double tragedy, she went into shock and fell into a deep depression. It took only days before she decided to take her own life. She used her barstool to hang herself in the parlor of her home.

At the time of their deaths, the local undertaker only had two seven-foot coffins available. He gently placed Miss Bonnie into one of them, with her famous bar stool in the foot of the casket.

When he tried to fit Slim into the other coffin, he had to bend Slims legs to get him to fit. The coffin was six inches shy of Slim's height.

Bonnie and Slim were laid to rest next to one another in Pinewood Cemetery. The horse was buried in front of the old livery stable.

On foggy, cold nights if you listen, you can hear the clip-clop, clip-clop of Slim's horse on Halifax Avenue as she tries to find her way to the livery stable. Some of the locals claim that when the fog is just right, you

can hear Slim kicking from inside his coffin. They claim he is trying to straighten his legs out. Poor Miss Bonnie has been seen, photographed and videotaped standing on her stool next to Slim's grave, waiting to give Slim his final kiss goodnight.

22

Coffins by Tappy

In Daytona Beach, as in many tourist towns, the availability of alcoholic beverages never seems to be a problem. Visitors and locals alike enjoy relaxing with a few drinks now and then. Whether you've had a nice relaxing day on Daytona Beach or worked hard and want to unwind a bit, there is nothing like an ice-cold beer on a warm evening. One such hardworking local, who enjoyed a few cold beers now and again—and again—was a resident of Daytona Beach during the early 1900s. He was the local coffin maker. The locals nicknamed him "Tappy."

Tappy had a little different view of his workday than most folks of that time period. Instead of waiting for his workday to be through, Tappy took nice long breaks in the middle of the day, so he could toss back a few cold ones. From about two o'clock in the afternoon until seven o'clock in the evening, Tappy could be found on his favorite barstool at the Brass Rail Tavern. He became so well know in the tavern that many of the locals set their watches by Tappy's Happy Hours—yes, "hours," plural!

After his happy hours were through, Tappy returned to his workshop for a long nap. It was widely known throughout the town that Tappy napped inside one of the coffins. When he would awake, he returned to his job of making more coffins. This was normally done when most people were at home, sound asleep in their beds. Between two and three o'clock in the morning, when Tappy awoke from his daily nap, anyone walking the streets could hear the tap, tap, tapping of Tappy and his coffin nails.

Tappy's workshop was located upstairs from the Baggett & Weatherby furniture store, which is now the site of Tombstone Jewelry, on Main Street. The workshop was all a coffin maker could ever want or need. It had comfortable sleeping arrangements, a quiet work environment

and even a chute to slide the finished coffins down to street level. One drawback was the eerie noise the coffin nails made as the finished coffins slid down the chute, but Tappy's customers never complained.

Since he was the coffin maker and such a good customer of the tavern, the employees of the tavern saved the empty bottles for Tappy. He carted them back to his workshop and used them to mold the ruffling of the satin lining inside the coffins.

Tappy also became famous for accidentally swallowing coffin nails and lining tacks. Like any good upholsterer, Tappy held the nails and tacks in his mouth while working. Since his happy hours were quite important to him, many a coffin nail and lining tack found its way into Tappy's digestive tract. Please do not try this at home; Tappy was a professional!

Tappy shared this unusual practice with some of his friends at the Brass Rail Tavern, and instead of suggesting that Tappy remove the nails and tacks from between his lips before taking a drink, they parlayed Tappy's drinking problem into a local drinking game. They handed him strange—and often sharp—objects and told him that if he swallowed them, they would buy his next cold beer for him. One evening after happy hours, Tappy returned to his workshop for his nap. Little did he know that this would be his last trip to the tavern and an everlasting nap.

The following morning, the owners of the furniture store began to worry about Tappy. By ten o'clock they hadn't heard the familiar tapping sounds coming from the coffin shop upstairs. When they went to check on Tappy, they found him lying in a coffin where he had bedded down for the night. He had died in his sleep.

When the undertaker arrived and pronounced Tappy dead at 10:30 a.m., he added that there would be no need to embalm Tappy, as his alcohol content had seen to pickling him! The undertaker then wrote on Tappy's death certificate that he had died from iron poisoning. However, Tappy's abdomen was black and blue and distended, which would lead one to believe that he had punctured an internal organ!

The undertaker closed the lid on Tappy's coffin, and when he slid it down the chute at eleven o'clock, it made the eeriest screeching noise. The sound of Tappy's coffin, with the weight of him inside, was louder than the sound of the empty coffins sliding down the shoot, and the intensely loud sound echoed across town.

Tappy was buried in Pinewood Cemetery, along with many of his clients. It is said that if you are near the east side of the cemetery at eleven o'clock in the morning, you can hear the screeching sound of coffins being slid down the coffin chute.

Some locals and police patrolmen have reported strange tapping noises—in the dead of night—coming from the upstairs rooms over the building that is now Tombstone Jewelry. If you are brave enough to stand in front of the old coffin maker's workshop, listen carefully; you may be lucky enough to hear the tap, tap, tapping of Tappy and his coffin nails from the old coffin shop upstairs.

23
Spirits of the Ponce de León Inlet Lighthouse

There isn't a coastal lighthouse town in the world that doesn't boast having a spirit or two attached to the lighthouse tower itself. Ponce de León Inlet Lighthouse, just south of Daytona Beach, is no exception.

What is it about a lighthouse that seems to attract and hold spirits? Is it the bright beacon that attracts spirits to lighthouse towers? Is it the often-treacherous locations and consequent severe shipwrecks and sometimes-tragic deaths? Or could it be the lighthouse keepers, faithfully attending to their lonely duties in the afterlife?

The Ponce de León Inlet Lighthouse is unique among lighthouses. Its foundation is 12 feet deep and 45 feet wide and soars skyward 175 feet. One-and-a-quarter million bricks were used to construct the tower that is 32 feet in diameter at its base and 12 1/2 feet in diameter at the top. The walls of the tower are 8 feet thick at the base and 2 feet thick at the top. There are 203 steps on the iron spiral staircase that lead to the gallery and a weight well located centrally at the base to catch items that fell down within the tower.

The inlet where the lighthouse stands has long been known as one of the most treacherous in the Southeast. Since 1565, when the entire French fleet of Admiral Jean Rebault was wrecked by a hurricane in the vicinity of this inlet, many ships and lives have been lost here.

The inlet was explored by Captain Antonio de Prado in 1569 and named los Mosquitos because of the large number of insects that inhabit the area. Captain Álvaro Mexía charted the inlet in 1605, but except for the planting of a few orange groves, the Spanish never settled the area.

When Great Britain gained the Province of Florida in 1763, plantations were settled in this area, and commerce became so great that the Colonial

government maintained a beacon, or daymark, at the entrance to Mosquito Inlet, as it was then named. Spain regained the colony in 1784, but the plantations languished.

After Florida passed to the control of the United States in 1821, the plantations revived, and the need for a lighthouse at this dangerous inlet was recognized as early as 1822. However, it was not until June 30, 1834, that Congress appropriated $11,000 for the construction of the tower.

John Rodman, collector of customs for St. Augustine, chose a site on a twelve-foot-high dune on the south side of the inlet. Winslow Lewis completed the forty-five-foot-tall brick tower by February 1835, at a cost of $7,494, including the installation of fifteen of his lamps that each had sixteen-inch silvered parabolic reflectors. William H. Williams, a local pilot, captain and son of a prominent local plantation owner, was selected as the lighthouse keeper, and he moved into the new keeper's quarters. However, oil for the lighthouse never arrived, and the lamps were never lit.

In October 1835, a hurricane struck, washing away the keeper's quarters and undermining the foundations of the lighthouse enough to cause it to lean. Keeper Williams and his family abandoned the area and moved back to his father's plantation.

In an attack by Seminoles on December 26, 1835, which ignited the Second Seminole War in Florida, the Native Americans climbed the lighthouse, smashed all the glass in the lantern, set fire to the wooden stairs, and absconded with the lamp reflectors. The leader, Chief Coácoochee, wore one as a headdress at the Battle of Dunlawton three weeks later. The Native Americans won the battle, and the entire area was abandoned.

No one could come to repair the leaning lighthouse, and in April 1836, it finally toppled into the sea. It would be more than fifty years before Mosquito Inlet would get another lighthouse.

The Ponce de León Inlet Lighthouse, which had begun as the Mosquito Inlet Lighthouse when the ten acres of land was purchased on March 21, 1883, was now ready to be built. Francis Hopkinson Smith, a noted writer and engineer, designed the lighthouse. It was declared by lighthouse inspectors "the most beautiful and best proportioned tower in the district." Chief Engineer Orville E. Babcock was the first official victim of the lighthouse; he drowned in the inlet as construction was to begin in 1883. The tower was completed four years later, despite being rocked by the great Charleston Earthquake of 1886.

Keeper William Rowlinski first lighted the kerosene lamp on November 1, 1887. The new light could be seen from twenty miles at sea. Rowlinski, a Russian immigrant, served until 1893, when he transferred to a lighthouse

Chief Coácoochee. *Courtesy of State Archives of Florida.*

in South Carolina. When he retired in 1902, he bought a house on the Halifax River, right next to his old lighthouse at Mosquito Inlet.

Thomas Patrick O'Hagan, a staunch Irish Catholic who moved to the light station with his wife and four children, succeeded Rowlinski as principal keeper. Before he left in 1905, O'Hagan had seven more children before moving on to the Amelia Island Light Station.

In 1897, while O'Hagan was here, author Stephen Crane was shipwrecked offshore. John Lindquist, a Swede, became principal keeper in 1905. In 1907, a new well was dug and a windmill and water tank tower were built to provide a more reliable water supply. In 1909, an incandescent oil vapor lamp replaced the kerosene lamp. Lindquist served until 1924.

The 1920s were a period of great change at the Mosquito Inlet Lighthouse. In 1925, under Principal Keeper Charles L. Sisson, a generator was installed in a new small building and electricity was brought into the keepers' homes for the first time. An electric water pump replaced the old windmill. In 1927, the name of Mosquito Inlet was changed to Ponce de León Inlet.

John B. Butler became principal keeper in 1926, and in August 1933, the tower light was electrified with a 500-watt electric lamp. At the same time, the old first-order fixed lens was replaced by a third-order revolving flashing lens. The position of assistant keeper was abolished, but a relief keeper was stationed there to lend a hand. After Edward L. Meyer became principal keeper in 1937, a radio beacon was established in a vacant dwelling on the south side of the light station.

In 1939, the lighthouse was transferred from the abolished Lighthouse Service to the coast guard, and Edward L. Meyer, the last civilian keeper at this station, joined the coast guard. During World War II, the keepers' families left the light station and the buildings were turned into barracks for the coast guardsmen who protected the light and stood watch against enemy submarines. Meyer related many exciting times in the light station journal during the war.

After the war, families moved back, but in late 1953, the lighthouse was completely automated, and the keepers and their families left for the last time.

In 1970, the coast guard abandoned the old light station and established a new light at the coast guard station on the south side of the inlet. Vandals did much damage to the lighthouse and outbuildings, including setting fire to the oil house building. Two years later the abandoned property was deeded to the Town of Ponce de León Inlet.

In 1972, the Ponce de León Inlet Lighthouse Preservation Association was founded as a nonprofit organization to assist the Town of Ponce de León Inlet with the restoration and management of the light station. In

1972, the light station was listed on the National Register of Historic Places as one of only a handful of nineteenth-century light stations to have all its original buildings still intact.

Through the efforts of the dedicated volunteers of the preservation association, the damage done by vandals was reversed and full restoration had begun. In 1982, a new tower balcony replaced the crumbling one, and the light in the lantern was restored to active service. The three keepers' dwellings have been converted into museums—a lighthouse museum, a sea museum and a period house museum. Their woodshed, privies and the oil storage building are all still on the grounds. In 1995, the first-order lens from Cape Canaveral was restored and placed on display in a new building. The paint on the lighthouse was created as a special blend from Germany that resists fading for fifty years. The glass is bulletproof to avoid any breakage from birds or other objects impacting the glass.

With the great skill and care taken to build and man the Ponce de León Lighthouse, and the many lives lost during its history, we can at this point only guess at whose spirit may still be on the grounds.

Keeper John Belton Butler (1871–1948), served from August 20, 1926, until July 2, 1937. Born in Charleston, South Carolina, on October 18, 1871, twenty-seven-year-old John Belton Butler joined the Light House Establishment in 1899, serving first on the lighthouse launch *Snowdrop*. Butler later served the Charleston, Cape Canaveral and Jupiter Light Stations. In 1902, Butler married Mamie Wilhelmina Witzel, and they raised six children. In August 1926, Butler was promoted to principal keeper of Mosquito Inlet Light Station.

While the Mosquito Inlet area was going through dynamic changes in the mid-1920s, major construction was under way in the area, and on June 1, 1927, the name of Mosquito Inlet was officially changed to Ponce de León Inlet. Butler was often commended for his rescue of many small boats wrecked in the area. In October 1927, two huge, iron oil tanks were installed in the oil house.

In December 1932, Butler and his family watched as President Herbert Hoover sailed past on the *Sequoia*. In 1933, the tower light was electrified and a revolving third-order lens replaced the old first-order lens. Keeper Butler took good care of the Ponce de León Inlet Lighthouse for eleven years, but finally, in June 1937, he retired from the lighthouse service. He moved with his family to Hawthorne, Florida, where he lived until his death on November 5, 1948. He is buried in the cemetery at Melrose, Florida.

The most likely candidate for a haunting at the tower is the spirit of Joseph B. Davis. Born in 1860, Davis was the second assistant keeper from

1914 until 1916, and in December of 1918, he became the first assistant keeper of the lighthouse. On a Sunday in October of 1919, Davis climbed the stairs in the tower to light the lamp. As he neared the top of the stairs, he suffered a fatal heart attack. The second assistant keeper, Ben Stone, noticed the lamp had not been lit, and climbed the stairs to assist Davis with whatever problem may have prevented the lamp from being lit on time. Stone discovered Davis's body and carried him down the tower. Davis was laid to rest in the cemetery in Coronado Beach, now known as New Smyrna Beach. It is said that his spirit still climbs the stairs to finish his duties. Every Sunday at approximately 5:30 p.m., near the top of the tower staircase, a chilly breeze can be felt. It is also said that the steps where Davis's body was found will not hold paint. No matter how many coats of paint are applied to those particular steps, it always seems to fade faster than on any other steps in the tower.

24

The Will-o-the-Wisp

Many traditions, beliefs and cultural traits crossed the Atlantic Ocean with the people who settled this great nation. People came from many different places and traditions, and we now have one of the most diverse societies in the world. We also have the freedom to choose whether we wish to adopt these traditions as part of our personal belief systems. Many of these legends can be put into the general category of what is known as "ghost lights," but some cultures have given these anomalies very specific names. Several frightening stories have withstood the test of time.

Legends include the banshee, the kelpies, the jack o' lantern and will-o-the-wisp. Whether these legends were originally based on any solid evidence, we may never know. But some people believe in these legends so strongly that they have risked and lost their lives to them.

The Irish brought the best example of a deadly legend. The banshee was seen as a long-dead virgin belonging to the family. At first it was seen as a good, grieving spirit who appeared to warn a family member of a certain death, but after a time, the legend evolved to the point where the banshee lost its grief and sympathy and became just an evil messenger of death. As the tale evolved even further, the banshee's song transformed from a warning message to the reason that someone was about to die.

The Scottish version of the banshee—who, unlike the Irish version—is anything but beautiful; she has one nostril, one large tooth and webbed feet. She is usually spotted at the riverside, washing the clothes of one who is destined to die.

In the days prior to Daytona Beach's incorporation, many settlers in the area reported seeing the Scottish version of the banshee along the banks of the Halifax River. Could it simply have been their imaginations,

Manatees may have been mistaken for the Scottish banshee. *Courtesy of Dusty Smith.*

or possibly the strange-looking manatees that inhabit these waters? Or could the banshee have been real and called an early settler or two into the murky waters of the Halifax River to their death?

The Scottish kelpies were spirits of water who left their watery homes to find victims whom they might drown. In order to accomplish this, the kelpie changed form into a magnificent horse, a handsome, seaweed-haired young man or a hairy man and lured people into lakes and rivers. A tale of a kelpie taking young lives in the Daytona Beach area is told like this:

> *Seven little girls were out walking on a Sunday and saw a pretty little horse walking near the edge of the Halifax River. One after another, they got on the horse's back. Gradually, the horse lengthened itself so that there was room for all the little girls. A little boy who was with the girls noticed the strange behavior of the horse and refused to join the girls who were riding it. The horse turned its head and suddenly yelled "Come on, little scabby-head, you get up here, too!" The boy ran for his life and hid among the scrub palms where the strange horse could not get at him. When the horse*

saw that it could not gain another rider, it turned and dashed into the river with the little girls on its back. Only partial remains of the little girls' bodies ever washed up on the riverbank.

The kelpies also had other ways to lure their victims into the water. For example, another Scottish version of the kelpie lured victims into underwater domains by leaving gold or jewels floating on the surface of the water and abducting the people who reached for them, taking them into subterranean caves where they were used as slaves. According to some of these tales, if you first blessed the floating treasures, the kelpies were unable to grab the victim and the treasure was safe for taking.

Quite obviously, some these tales were used to make children cautious of rivers and lakes so that they would not drown in them accidentally.

Another legend that seems to have stronger roots from the South rather than being imported is of jack-o-lantern. Jack-o-lantern's light was often seen in the marshes, swamps and along riverbanks at night. The light appeared, receded and appeared again. Curiosity and the lure of the light beckoned the unsuspecting wanderer to follow the light. Often the wanderer fell into the swamp, marsh or river and drowned. According to folklore, Jack was once a real man—a human who sold his soul to the devil!

Upon Jack's death, he outsmarted the devil and was sent to heaven. Heaven refused him entrance, and thus Jack was left to wander the earth for eternity. Seeing Jack's predicament, the devil had pity on him and threw him a burning ember from hell. Jack then placed the ember into a carved turnip to light his way. This was Jack's light, and soon evolved into "Jack-O-Lantern."

Another legend that may be one of the predecessors of what are now called ghost lights is that of the will-o-the-wisp. Will-o-the-wisps are the faint lights seen on marshes and bogs on still nights after sunset. These lights are usually soft bluish-, reddish- or greenish-colored balls of light. In folklore, they are thought to be impish spirits leading victims to danger in swamps, marshes, bogs and along riverbanks. In some folklore they are believed to be the spirits of stillborn children flitting between heaven and hell.

A resident of the Daytona Beach area, Mr. Harding, told one story of the will-o-wisp ghost lights. While working on a ship that was collecting sea sponges, a terrible storm blew in. As the crew tried desperately to secure the cargo and keep the listing ship from sinking, they witnessed balls of fiery light coming out of the sky and soaring toward their ship. Just before it seemed the balls of fire would hit the ship, they burst and disappeared.

Another local tale is told of the Ormond ghost lights. These will-o-wisp ghost lights can be seen on the road that cuts through Tomoka State Park, all the way up to Highbridge Road Many locals have tried to explain these lights away by saying they are swamp gas or phosphorous algae growth. The most popular story is of the Native American warrior who was determined to visit the daughter of the chief of the neighboring tribe. His father forbade him to leave the tribal camp, but he made a torch from lighter knot and ventured into the darkness to find the young maiden. As he tried to find his way through the dense brush, the warrior lost his way. He never found the maiden, never found her camp and never found his way home. It is said that his spirit still roams through the forest with his torch in search of the maiden or his home. Because he never found his way, it is said that if you try to follow his torch, he will lead you astray.

The Will 'O Wisp
By Jack Prelutsky

You are lost in the desolate forest,
where the stars give a pitiful light.
but the far away glow of the Will of the Wisp,
offers hope in the menacing night.

It is lonely and cold in the forest,
and you shiver with fear in the damp.
as you follow the way of the Will of the Wisp,
and the dance of its flickering lamp.

But know, as you trudge through the forest,
toward that glistening torch in the gloom,
that the eerie allure of the Will of the Wisp,
summons you down to your doom.

It will lead you astray in the forest,
over ways never traveled before.
if ever you follow the Will of the Wisp,
you'll never be seen anymore.

About the Author

Dusty Smith is known throughout the paranormal community as "the Ghost Lady," a nickname acquired after being certified as both a ghost hunter and paranormal investigator. She is the president and founder of the Daytona Beach Paranormal Research Group, Inc. and its sister organization, the International Association of Cemetery Preservationists, Inc. Additionally, she is the owner and chief operator of Haunts of the World's Most Famous Beach Ghost Tours and co-host of *Magick Mind Paranormal Talk Radio*.

Literary works include *Dread & the Dead Filled the Dunnam House*, numerous articles penned as a staff writer for *Epitaphs Magazine* and several short stories published in works compiled by various authors in the paranormal field.

Dusty has been a lecturer at many paranormal conferences and has been featured on the Discovery Channel's series *A Haunting*. She has also filmed three documentaries about the paranormal.

Dusty's passion for the paranormal and history has led her down her spirit-filled path. For a frightfully ghoulish time, enter into Dusty's world and read the documented true hauntings associated with the otherworldly residents of the Daytona Beach area!

Please visit us at
www.historypress.net